MASTER BREASTS

Juan Carlos Alom
Merry Alpern
Nobuyoshi Araki
Beth B
Ralph Bartholomew
Hans Bellmer
Lynn Bianchi
Brassaï
Lizzie Calligas
Henri Cartier-Bresson
Stephen D. Colhoun
Lisa Crumb
Imogen Cunningham
Bruce Davidson
Lynn Davis
Baron Adolph de Meyer
Elliott Erwitt
Donna Ferrato
Karen Finley
John Flattau
Robert Flynt
Kevin Funabashi
Jean Gaumy
Paolo Gioli
Nan Goldin
Douglas Kent Hall
Eikoh Hosoe
Connie Imboden
Peggy Jarrell Kaplan
Michiko Kon
Dorothea Lange
Helen Levitt
Judy Linn
Mark Lyon
Sally Mann
Robert Mapplethorpe
Mary Ellen Mark
Matuschka
Dona Ann McAdams
Fred W. McDarrah
Susan Meiselas
Duane Michals
Richard Misrach
Jack Mitchell
Yasumasa Morimura
Shirin Neshat
Michael Nichols
Paul Outerbridge
Paolo Pellegrin
Carollee Pelos
Marta María Pérez
Jack Pierson
Adrian Piper
Man Ray
Eugene Richards
Miguel Rio Branco
Martha Rosler
Andres Serrano
Cindy Sherman
Harry Shunk
Annie Sprinkle
Tono Stano
Bert Stern
Alfred Stieglitz
Philip Trager
Yves Trémorin
Eugenia Vargas
Eugene von Bruenchenheim
Edward Weston
Hannah Wilke
John Willis
Francesca Woodman

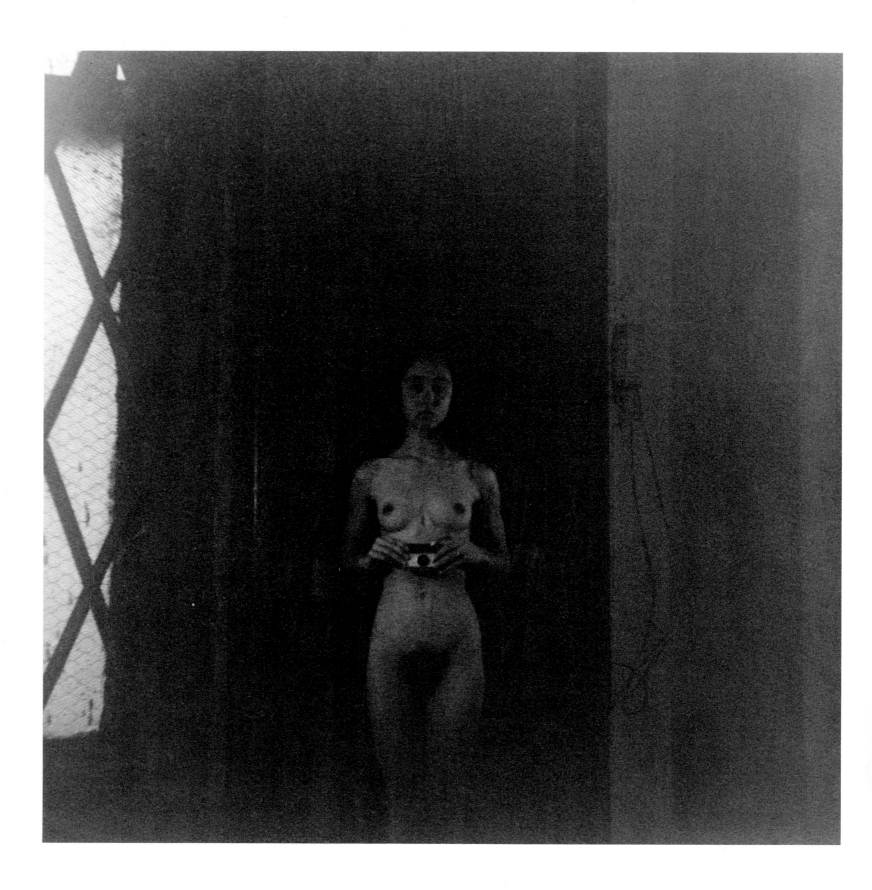

MASTER BREASTS

OBJECTIFIED, AESTHETICIZED, FANTASIZED,
EROTICIZED, FEMINIZED BY PHOTOGRAPHY'S MOST
TITILLATING MASTERS. . .

INTRODUCTION ❧ FRANCINE PROSE

THE DETECTIVE ❧ KAREN FINLEY
THE STORY OF THE TIGER ❧ DARIO FO
BREASTS ❧ CHARLES SIMIC

APERTURE

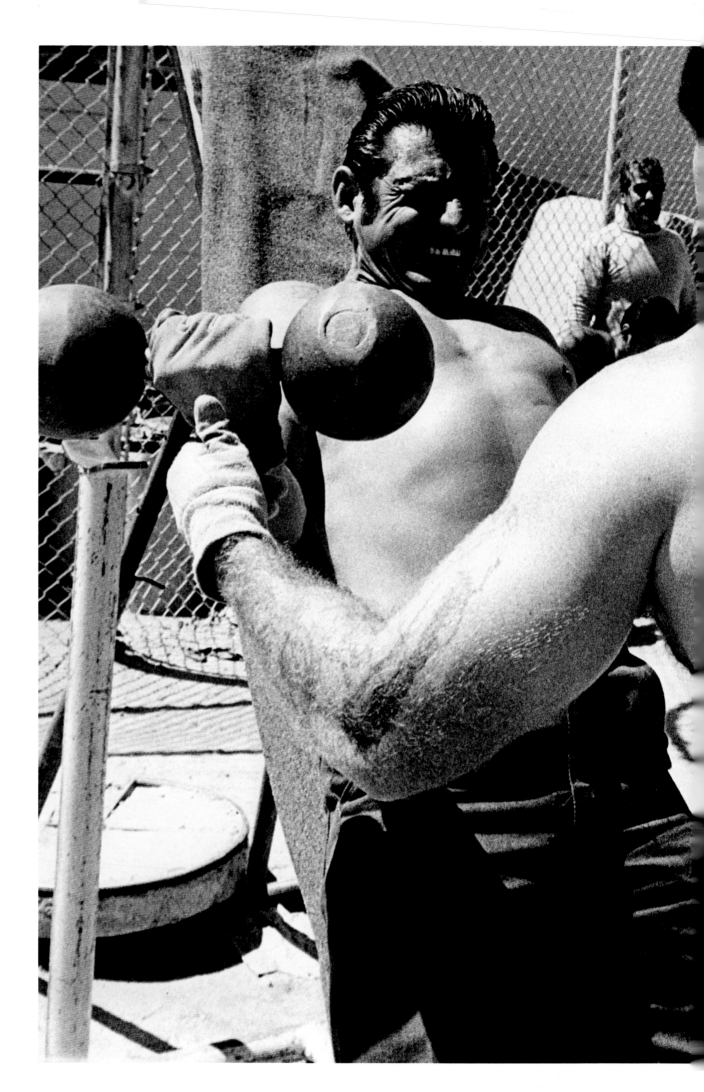

4

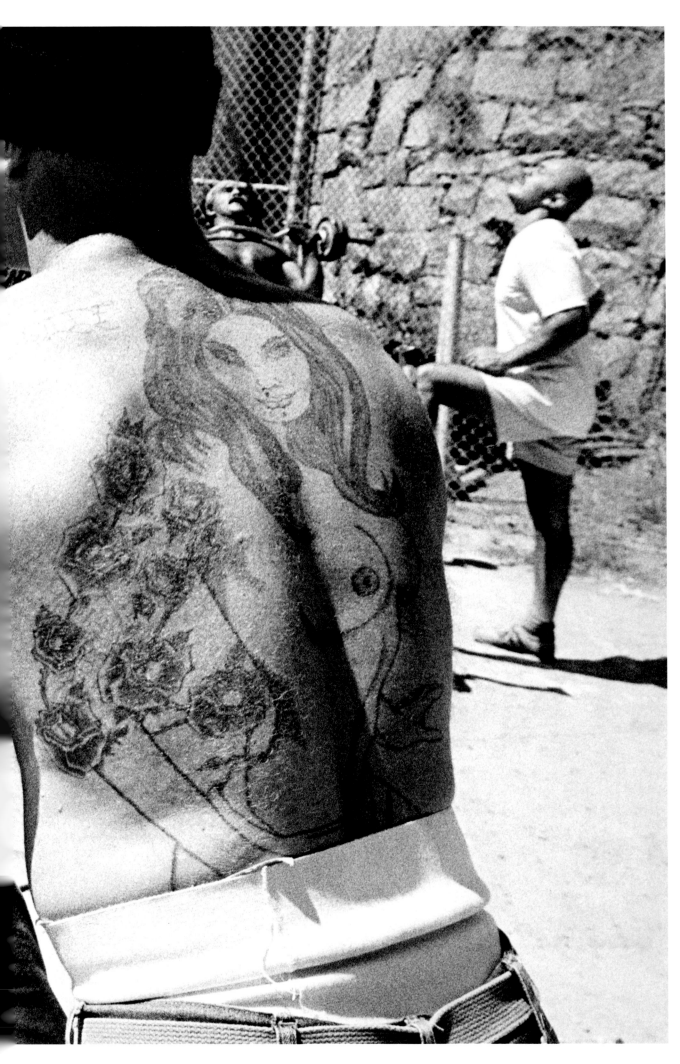

Page 2: Adrian Piper,
Food for the Spirit, 1971

Left:
Douglas Kent Hall,
The Weight Pile,
Folsom Prison, 1980

5

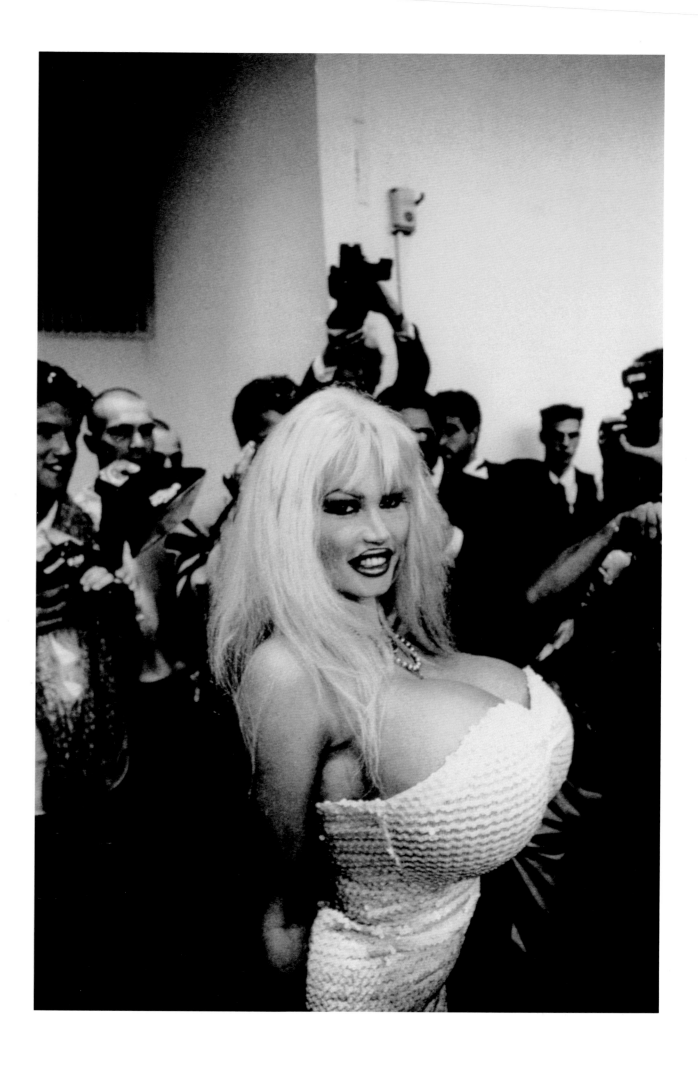

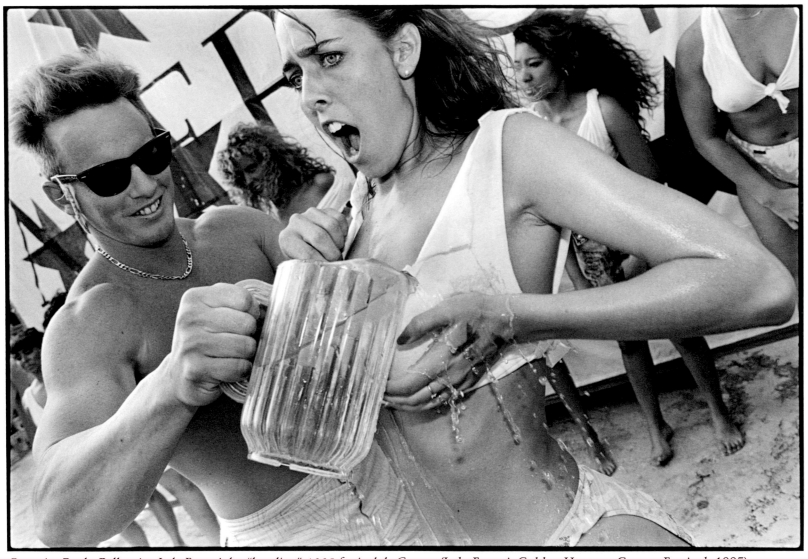

Opposite: Paolo Pellegrin, *Lolo Ferrari, les "hot d'or," 1995 festival de Cannes* (Lolo Ferrari, Golden Hostess, Cannes Festival, 1995)
Above: Mary Ellen Mark, *Wet Bathing Suit Contest, Spring Break*, Daytona, Florida, 1991

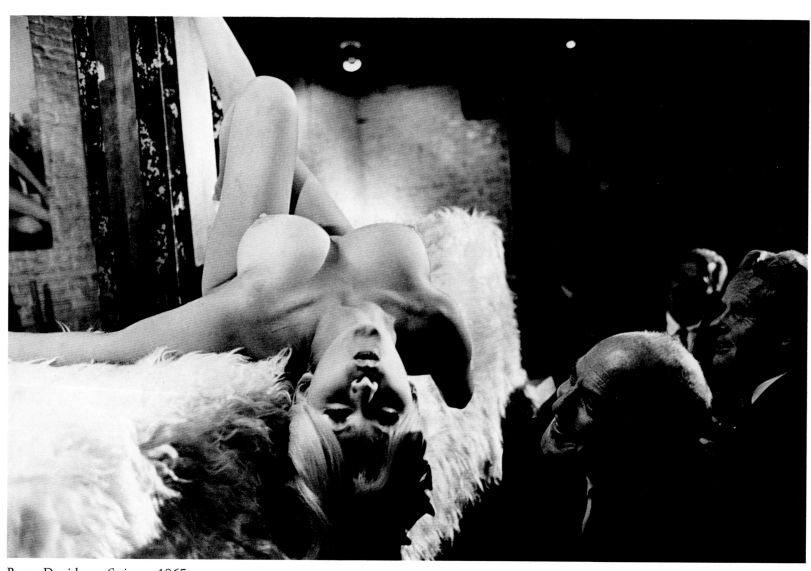

Bruce Davidson, *Stripper*, 1965

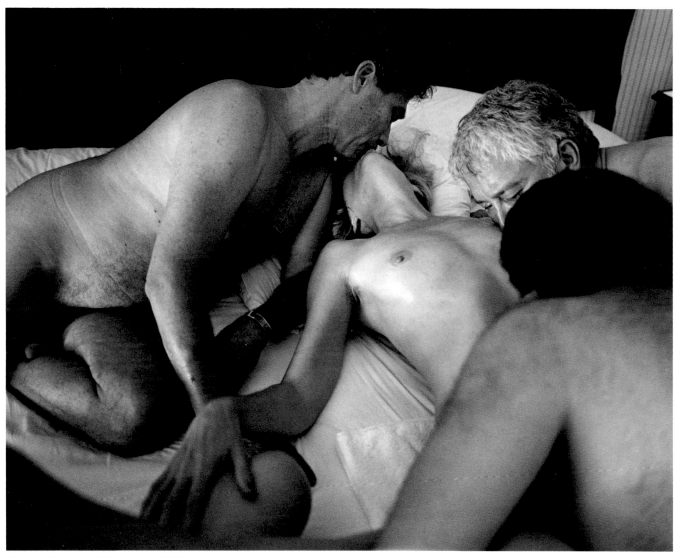

Donna Ferrato, *Swingers*, 1995

INTRODUCTION

BY FRANCINE PROSE

The photo that no one thought to take, but that I can still see sharply, preserves forever the moment when I learned what breasts were for. It was Halloween, I was thirteen years old, there was a costume party, a little, I suppose, like the masked artists' ball in the Brassaï photograph, though with some obvious differences. My classmate's Halloween party was in the atomically bright living room of his middle-class family's New York apartment, and the guests were awkward private-school children on the scary cusp of adolescence, while Brassaï's gala masked ball, held among the shadows and lamps of the *louche* Parisian night, was jammed with naked or half-naked adults, leering sexily at each other.

How precious is this photo of the party we'll never go to, with its young men in loincloths, holding spears, the upturned funnels on their heads like chimney pipes to vent the testosterone burbling inside, costumed as centurions from some loony planet, bestowing sheeplike adoring gazes on a beautiful young woman. The woman is costumed as an erotic, exotic Orientalist fantasy of a dancing girl: nude but for a spangled G-string and a Cleopatra wig. We can't see her expression; her face is turned toward the men. But her costume—her perfect body, her breasts—gravitates toward the camera.

Brassaï isn't the only master in *Master Breasts* who shows us breasts-as-costume. Consider the otherworldly bras that have made their way into the photos of Lisa Crumb and Michiko Kon. Crumb discovers hers at a public beach, on an older woman whose bathing attire suggests the Statue of Liberty made over with the inventive fashion sense of certain UFO cultists, while Kon creates her mysterious garment, its cups and straps upholstered in gleaming filets of silver and polka-dot gizzard shad. In Dona McAdams's portrait, the performance artist Pat Oleszko has painted her breasts like the finger puppets children scrawl on their hands. With the help of long black gloves, Annie Sprinkle choreographs her "Bosom Ballet," a hilarious, cartoonish mammary *pas de deux*—culminating

here in the Prom Queen so pleased with her zany yin-yang breast corsage. Sally Mann's daughter Virginia (in her mother's photograph of her) understands the theatrical aspect of breasts before she even has them, and the outsize bosom plays a major role in Cindy Sherman's witty revivals of the Old Masters.

Of course, breasts are a part of fashion, of costume, but the images in *Master Breasts* dig deeper, delicately unearthing and gently dusting off long-buried memories of having "put on" our breasts. The shock, for girls, of developing breasts, a concept which men cannot grasp, is the shock of finding ourselves with a body part that we didn't start out with.

More than a new body covering—like pubic, facial, or armpit hair, easily concealed beneath clothes or shaved daily out of existence—breasts are whole new organs, two of them, tricky to hide or eradicate, attached for all the world to see: outside, front and center. At that most confusing, chaotic age when every word and gesture heralds a skirmish for power and self-determination, breasts arrive as twin messengers announcing our lack of control, announcing that Nature has plans for us about which we were not consulted.

*

Until that Halloween night, I'd imagined—stupidly, as it turned out—that breasts were a way of measuring yourself against other girls, of seeing where you stood in the procession—rushing or trudging, dragged, kicking and screaming—the Long March toward female adulthood. A. had breasts. B. and C. didn't. D.'s were already large. It was public knowledge, and clinical: competition without rancor. I didn't envy D. her breasts. I didn't have the time; I was too busy fearing (hoping, perhaps) that I would never have them. Besides, we girls were still not completely differentiated, so D.'s breasts were almost like *group* breasts as we clung together in squirming lumps, squealing like litters of piglets. But that was part of the message that breasts were about to bring: breasts

were yet more physical evidence that we were separate, on our own, or in the process of turning into our singular lonely selves.

Of all the photographs in the book, only Beth B's wittily suggests the possibility of nipple-to-nipple conversation. Imogen Cunningham invites us to admire the bodies of two women with lovely breasts, but who are, as it happens, headless, their beauty so formal and abstract that they could be two green peppers in an Edward Weston still life.

Otherwise, the subjects of most of these photos are alone with their breasts— for all we know, alone on the planet—though naturally we intuit the presence of a male or female photographer, acknowledged or (in Merry Alpern's voyeuristic glimpses from opposite windows) apparently unsuspected. Dorothea Lange's nursing mother has company in the picture frame, though the weight of the baby seems to be part of her trouble. Mary Ellen Mark's laughing woman and the child in the crook of her arm seem as comfortable and at ease in their bodies as the family dog. The woman receiving the avid carnal attentions of three men in Donna Ferrato's photo has, obviously, all the

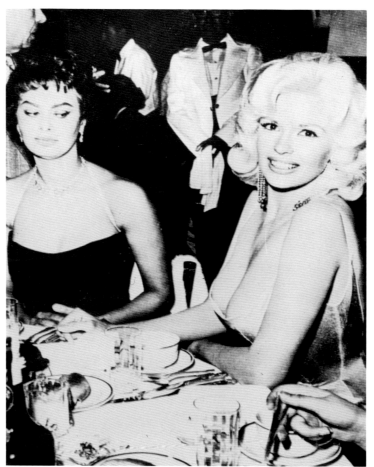

Anonymous, *Sophia Loren and Jayne Mansfield*, Romanoff's Restaurant, Hollywood, California, n.d.

company she could desire, and the merry trio of bare-breasted swingers sharing a bed in Elliott Erwitt's picture focus on the camera and not on each other. (What a very different photo that would have been!) With their coffee cups, their goofy grins, their shoulders hardly touching, they're the very picture of guilt-free, wholesome sexual freedom—unless we look, for a moment too long, at the woman on the left, the older and less beautiful one, distraction or strain freezing her smile for a melancholy, introspective half-second.

Perhaps, as always, we need the paparazzi flashing away in the starry night to show us the unexpurgated version of what we suspect but would rather not see. Who can—who wants to—read the complexity of expression in Sophia Loren's eyes as she (not exactly small-breasted herself) regards the prodigious endowments of her companion, Jayne Mansfield? Is it competition? admiration? contempt? Or does her sidelong glance measure the huge distance between the two women at the deceptively small nightclub table?

In the Helen Levitt photo, the women have been restored to an earlier stage, or advanced into a new one, when breasts are funny again. Easy for the woman who isn't pregnant to laugh at the breasts-as-milk-bottles joke! The pregnant one isn't laughing. But she knows it's a joke. It's her friend's joke, after all. They're women. They know what they know.

❧

The boys refused to wear costumes to the Halloween party. For weeks the girls talked and planned and changed their minds and thought of nothing else.

Did I have breasts yet? I don't think so. Or perhaps they were starting to grow. The memories of the body are cloudy, or unavailable, to the mind. Sex. A sunburn. Childbirth. It all blurs very quickly. I don't know what I remember, or how long the process took. Or, for that matter, how it felt. A soreness, maybe. Itching. Did breasts grow slowly, over time, or did they appear one morning, two fried eggs erupted overnight on our chests? Girls and boys alike, we were at once confused and thrilled by this terrifying evidence of metamorphic transformation.

I do remember (as do my friends, when I ask) that it was suddenly more difficult to run. Our new body parts

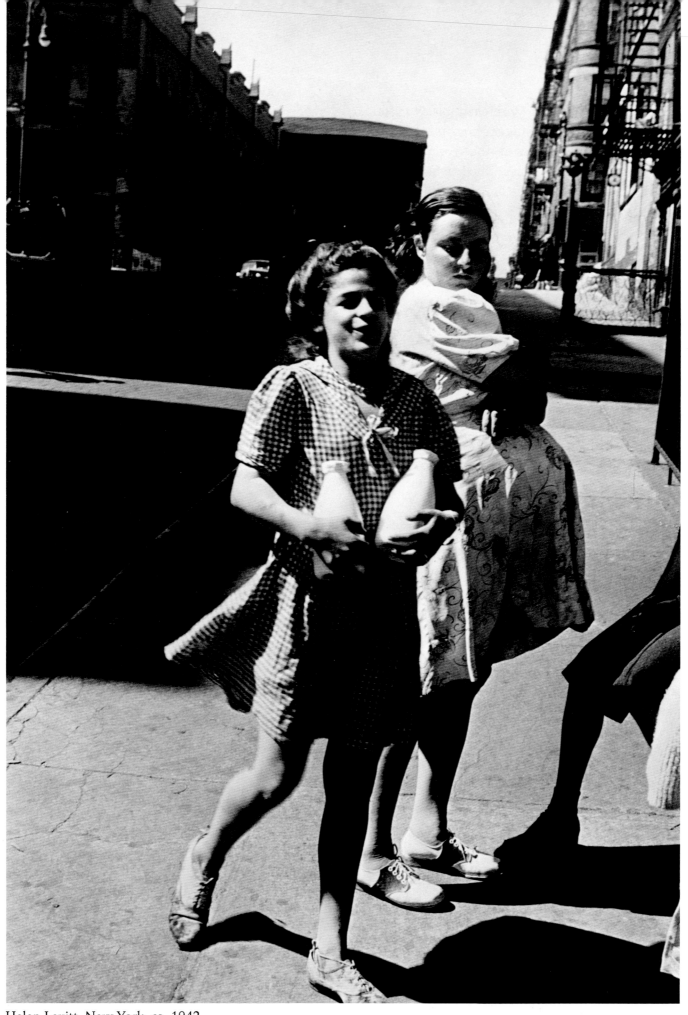

Helen Levitt, New York, ca. 1942

bounced, surprisingly, aching with each jolt. No wonder we couldn't understand why bigger breasts were better.

This was in 1961, when, like us, the world was poised on the edge. As we gingerly walked the line between child and adult, our culture hovered on the border between Jayne Mansfield and Twiggy. Of course, we know about fashion: big breasts are in vogue one year and in one culture, tiny ones are all the rage the next season and next door, with only a century or so separating Cranach's tidily spherical, clavicle-level globes from Rubens's fleshy goddesses with their generous heft, the pendulum moving faster, in rapidly narrowing arcs, until only decades divide Diana Dors from Kate Moss.

Is there an ideal of the beautiful breast, beyond the flavor of the moment? Edward Weston seems to think so, as does Manuel Alvarez Bravo. In his famous, iconic photograph of a nude young woman holding a pair of glass eyeballs on a tray, the ideal is naughtily underlined by the parochial-schoolboy dirty homage to the martyred female saints. The serious, funny, and painful joke is retold, with altered punchlines, in Marta María Pérez's modern takes on breasts and religious devotion. Georgia O'Keeffe's breasts are unlikely to grace the pinups of any era, and yet Stieglitz convinces us of their beauty. (The picture of Rebecca Strand's breasts does makes one begin to think that Alfred had a type, and to wonder if men can be imprinted–like ducklings–on a particular model of breasts.) The women in Nan Goldin's work have bodies whose beauty surprises us partly because the women seem so real (so unlike the romantic ideal) and partly because they must be separated out and viewed on their own, away from our expectations about the aestheticized and idealized image and setting we still associate with the traditionally "beautiful"–or "tasteful"–photo. Yves Trémorin's striking nude gives us a welcome push beyond seeing youth as beauty's cutoff point.

And yet there are things we expect from breasts, regardless of the moment. Though we know breasts are asymmetrical, we demand a vaguely congruent two-ness. Even without their associations with illness, fear, and danger, Matuschka's and Hannah Wilke's post-mastectomy photos have the power to upset us–and Dorothea Lynch, in Eugene Richards's picture, confronts us with the possibility of death stronger even than love. (It's because of what we do know that these photos remind us of how the media, the statistics, the facts of life and death have

made many of us think of our breasts as time bombs, waiting to go off inside us, like weapons that kill many, but slowly, and one at a time). Though we learn in middle school about the ancient mid-Eastern cultures that venerated many-breasted goddesses, the disjunction in Duane Michals's portrait of Louise Bourgeois is at once amusing and disconcerting. Once I read about a psychology experiment in which an infant coos and gurgles when shown photos of a woman's face, and has no response at all to faces with scrambled features. But a face with one eye out of place makes babies wail, and then scream.

To say that a behavior or desire or taste is primal, or, as we say now, hard-wired in the species, is to lift it beyond the reaches of will, of judgment and morality, beyond all praise or blame. The primal is something that can't be helped, and therefore shouldn't be minded. When our sense of the primal is mixed with our sense of the sacred, we're edging into areas that can hardly be put into words.

When an object (or body part) is worshiped for long enough, in enough disparate cultures, we just have to ask ourselves–eventually, finally–why. Judy Linn's photograph of the sculpture of the African female deity slyly compels you to look at the power emanating from the long, pointed (so unfashionable, so un-Western) breasts. And Tintoretto's painting illustrates the Greek myth which traces the creation of the Milky Way to a spray of milk from Juno's breast when it was yanked out of the mouth of the infant Hercules, a half-human, half-divine baby put there by Zeus–his divine, immortal, and adulterous father– to drink of immortality. Of the bodily mysteries–birth, sex, death, and so forth–the mystery of lactation and nursing is, by far, the least messy and the most efficient. (One of the amazements of nursing is, in fact, how ingeniously the portable, hygienic, perfectly warmed and seasoned, intensely-pleasurable-for-both-participants food-delivery system has been designed.)

So, is our fascination with breasts culturally determined? Is it merely a passing fashion of our species' current evolutionary phase? Tell that to the dreamy infant in Peggy Jarrell Kaplan's photo, slumbering in honeyed bliss, bathed in the protective glow of those two delicious planets.

❦

But by that Halloween night, we girls had forgotten what that sleeping baby knows, or, as seems more likely, we probably never knew it. We were postwar babies,

after all. Few of us had been breast-fed, fewer had ever seen a woman nursing. Nor for that matter had we seen many photographs of breasts, not counting the nudist magazine that my friend L. found in her father's drawer, or the pinups plastered, in those innocent days, all over the walls of garages, or in the demure-provocative Sunday paper underwear ads that Martha Rosler parodies in her photomontages.

But didn't such concealment make a kind of sense? As confused as we were about the purpose of breasts, it still must have seemed clear: among the many things one can imagine doing with breasts, baring them for the camera is not the first that comes to mind. (Though it does seem somewhat more "natural" than tacking them up to use for target practice, as revealed in Richard Misrach's photo.) We hear about so-called primitive people believing that images of the face are evidence of soul-theft. Then what can we surmise about photographic replications of that highly totemic body part, those magic givers-of-life? Perhaps this is the moment to point out how few photos we see of the penis, not counting the men of Robert Mapplethorpe's and Leni Riefenstahl's very different tribes.

If the distance of irony measures the haste and the number of steps taken backward in discomfort, then some of these subjects and their photographers seem to be retreating from each other at just below shutter speed. Irony gives us the courage to see and be seen, to photograph and be photographed with some relief from the knowledge of how weird the whole process is. Irony suffuses the cross-gender visual cues of Mapplethorpe and Serrano, the ballooning or hanging tits of Cindy Sherman's Old Masters, the coy and complex transaction between the viewer and Noboyushi Araki's subject, the unspoken conversation between Nan Goldin and her women about whether posing for photos is really just another unremarkable part of ordinary life, the jokes in the Annie Sprinkle shots, the Dona McAdams, the Helen Levitt, the anonymous vintage "porn" photo of breasts as two more pieces of fruit on a tray, Lynn Davis's bodybuilder, the baglike mask hiding the face in the photo by Baron Adolph de Meyer, the cloth flowers that Marilyn clasps to her chest in the portrait by Bert Stern.

Intuiting that we ourselves might find it unnerving to bare our breasts to the camera, we can only conclude that these women are different–braver than we are. Though our bodies and souls may resemble theirs, we distance ourselves from their images, from the Bellocq whores inhabiting their nakedness with more genuine ease than we can even pretend, to beautiful Josephine Baker, clad only in her bananas, to the tribal women in "documentary" anthropological photos, for whom the putting on of clothing is not an obvious–assumed–first step toward preparing oneself for the day.

The brilliant Elizabeth Bishop poem "In the Waiting Room" describes a moment in childhood, a sudden blast of consciousness brought on by a combustive exposure to *National Geographic*, the magazine in which generations of American children got their first permissible glance at naked breasts. In the poem, a seven-year-old named Elizabeth accompanies her aunt Consuelo and waits for her in a dentist's waiting room in Worcester, Massachusetts. It's February 1918. She's reading *National Geographic*, with its familiar racist kitsch, women with long necks wound round with wire–"like lightbulbs," a dead man slung on a pole–"long pig," good for eating. It's the photo of the women's "horrifying" breasts, together with her aunt's faint cry of pain, heard dimly from the office, that sends the child spinning off the edge of the world into the blue-black space of the fact, and the consciousness of the fact, of her own existence.

> I knew that nothing stranger
> had ever happened, that nothing
> stranger could ever happen.
> Why should I be my aunt,
> or me, or anyone?
> What similarities–
> boots, hands, the family voice
> I felt in my throat, or even
> the *National Geographic*
> and those awful hanging breasts–
> held us all together
> or made us all just one?
> How–I didn't know any
> word for it–how "unlikely". . .
> How had I come to be here,
> like them, and overhear
> a cry of pain that could have
> got loud and worse but hadn't?

I can hardly bring myself to describe the Halloween costume I chose for the eighth-grade party, the outfit I thought up and designed and made, over many evenings and weekends. My heart breaks now for that girl whose choice seems so thoroughly, sweetly transparent, so entirely and helplessly naked, even though I could hardly have been more excessively clothed.

other. Underneath the cardboard–tied at the shoulders with ribbon–I wore a (completely hidden) black leotard and black tights.

How creative. How pitiful. What in the world was I thinking? This, after all, was a party about which we girls had made certain calculations. Boys–definitely. Dancing–probably. Kissing–just possibly. Maybe. And I'd made

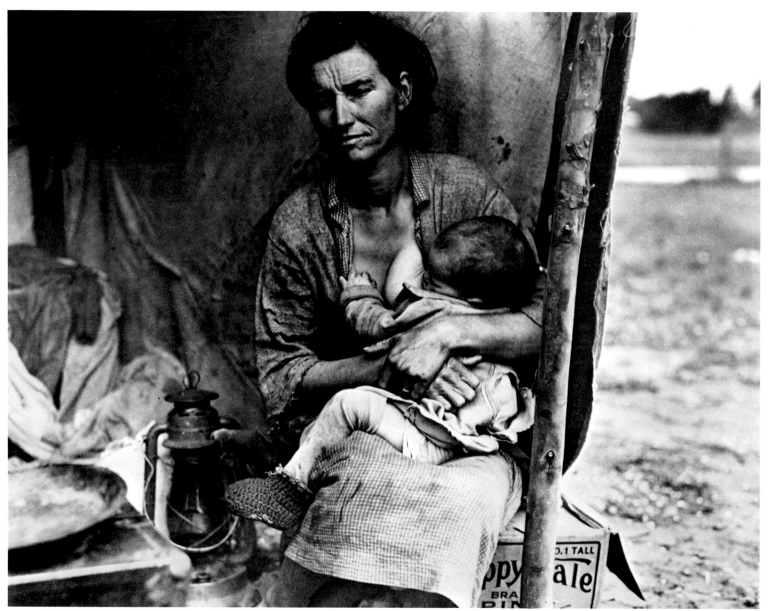

Dorothea Lange, *Migrant Agricultural Worker's Family*, Nipomo, California, 1936

God knows where I got the idea of dressing up as a playing card. I bought two sheets of light cardboard that reached from my neck to my knees. I rounded off the edges and spent days copying–with colored pencils, crayons, paint–colorful human-sized replicas of the Queen of Hearts on one side, the Queen of Diamonds on the

myself a carapace to ensure that no one could get close. Look, I was saying, I don't have breasts, or even, really, a body. Despite what may seem to be happening, I'm literally flat as a board.

In retrospect, cardboard covers seem a perfect–even prescient–outfit for a future writer. But at the time, all I

noticed, when I got into my father's car, was that, in my brittle sandwich, I couldn't even sit down. I wriggled out of my playing cards and set them gently in the back seat. My father dropped me off, and I slipped on my shell and headed into the party.

❧

Not long ago, my friend J. told me about a dream she had in high school. In J.'s dream, she was on a bus with her class from her all-girls school. A group of boys got on the bus. J. wanted the first boy to choose her, to sit down beside her. And in the dream she knew just what to do: she unbuttoned, and took off, her shirt.

What a useful dream to have! What helpful information! Perhaps it would have saved me from dreaming that the first boy on the bus would be drawn to a girl who was not just fully dressed—but fully encrusted in cardboard.

There was, as I've said, a girl named D., who already had large breasts. Though we would never have mentioned this, even to each other, we girls thought that her breasts were her consolation prize for being so hopelessly homely. Short and bowlegged, D. had a scrunched-up monkey's face and a strangely potato-colored complexion. She wore glasses (rhinestones, harlequin frames) to correct her slightly crossed eyes.

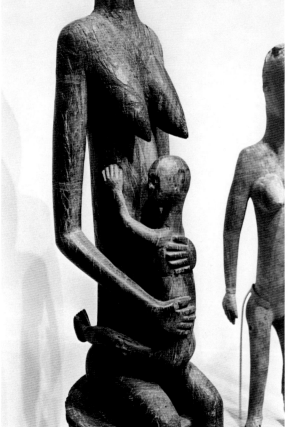

Judy Linn, Bamana sculpture, ca. 1993

D. came to the Halloween party dressed as some sort of Columbine, or Harlequinette, in a black leotard and tights (not unlike the filling of my cardboard sandwich), to which she'd added a short homemade ballet skirt in a bright diamond pattern.

Dance music played on the hi-fi. Potato chips glistened greasily in plastic bowls. Soda bottles were opened, surrounded by ice and cups. There were cut-out black cats on the wall, witches and grinning pumpkins, and our host's parents also grinned, though more anxiously, from behind the dining-room door. There were orange and black streamers and orange and black balloons.

And yet when D. took off her coat, the room emptied around her breasts.

The boys were the first to notice, of course. It took the girls a while to get it. After all, it wasn't as if we'd never registered the fact—the size—of D.'s bosom. So maybe it had grown since the last time we'd looked, or else the difference was what she was wearing: the skin-tight, low-cut black leotard, exposing a crevice of . . . cleavage. No breasts have ever seemed larger, though I suppose they were quite modest compared to those of the starlet, or whatever she is, in Pellegrin's photo, *Lolo Ferrari, les "hôt d'or" 1995 festival de Cannes.*

In the photo, a woman with what we can only assume are mammoth silicone implants smiles directly at us—straight into the eye of the camera. Her expression is generically sexy, inviting, a porn-film cliché of seduction, but bombed-out, wholly devoid of soul, of individuality, the mystery of the "other," of the questions and answers we associate with sex. To say that her gaze appears blank, or hard, is to miss the point. She has the air of a woman who has long gotten used to living with what must be an astonishing level of physical discomfort, to say nothing of the humbling fact that nothing about her will ever be as interesting or noteworthy as her breasts. The paparazzi clustered around her are leering, respectful, awed—they stand back, as if from something that may yet explode in their faces.

But the boys in my eighth-grade class had not yet mastered the art of watching and waiting, admiring from a distance. The sight of D.'s breasts drove them into a state of sexual frenzy. They began to run around wildly, shouting in an unintelligible language, falling all over each other, nearly trashing the apartment. They were the ones who seemed about to catch fire, or explode, and the girls drew back in alarm—except for D., who stood (was she frightened? proud? amazed?) at the quiet center of their hormonal storm.

*

Years later, I was assigned to write a magazine profile about a gifted and famous writer of memoirs. Before handing in the essay, I showed it to him, as I'd agreed, and of everything it contained—fairly intimate stories about his family and friends—the only line he asked me to delete was from the obligatory description of his study, his desk. I'd mentioned that beside his computer was a framed photograph of Annette Funicello as a teenager in the outfit (Mickey Mouse ears, pleated skirt, the sweater with her name across) that she'd worn on television, as a Mouseketeer on the *Mickey Mouse Club*. The memoirist asked if I would mind losing the reference to Annette.

Once more, I didn't get it. Still, I crossed the detail out. Not long ago, I thought about it, and my friend H. explained: Every weekday afternoon, for all those long, ennui-ridden, preteen years, H. and presumably the memoirist and the boys of their— that is, my—generation hurried home and turned on the television and stared at Annette Funicello's breasts. The names of the other Mousketeers stretched across flat shirts, but the letters that spelled out "Annette" rose and fell disturbingly over two perfect buds. It was not like Jayne Mansfield, H. says, because Annette was his age, and someone he saw every day, all alone, and he could look for as long as he liked, as long as the show lasted.

Their responses were the product of a homemade Pavlovian experiment, with Annette as the trigger. So I suppose the memoirist's photo of her was a devotional picture—used to generate emotion in much the same way as pictures of gods and saints. You can't blame someone for not wanting to tell the world about his personal shrine.

Perhaps the boys at the party responded the way they did because of the difference in intensity between the photo and the flesh. Or perhaps it was the fact of the group, combined with the nearness, the realness of D.'s breasts, which set off something instinctive, or something learned and practiced in front of Annette's image on TV. Whatever it was, the boys lost it, just fell apart—and rushed toward D. in a mass.

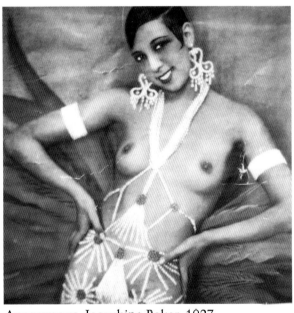

Anonymous, Josephine Baker, 1927

This is the image that I recall: the boys all clustered around D., not moving so much as swarming, trembling, like a hive of bees. We have all seen, or seen pictures of, those nests of tiny beings dislodged from their hive and hovering, humming in mid-air, glued together by the sheer sticky force of magnetic attraction. I don't remember the boys making a sound, or perhaps they really *were* humming. Buzzing, the boys surrounded D., and she vanished from our sight.

Was this a molestation? In the current climate of gender war, those boys could have been jailed for assault. But that wasn't how it struck us then. It just seemed a . . . phenomenon.

Later, D. said she hadn't been scared. The boys hadn't even touched her. I suppose we could have been frightened for D. But we were too busy being jealous. And, of course, surprised. All those weeks of planning and talking and getting ready, and the whole party had turned out to be about breasts.

*

In the photo that should have been taken, of the boys swarming around D., we can't actually see her breasts, but only the thrumming boys. And yet the image is eloquent, packed with information, facts streaming a mile a minute from that buzzing hive.

We were all learning a new language: boobs, knockers, tits, titties, bazangas, Francesca Woodman's melons, Helen Levitt's jugs. We were learning that breasts could move men to whatever preceded Richard Misrach's photos of target practice, or that the mere idea of breasts could generate a desire to be near them, a need so insistent and intense that the convict in Douglas Kent Hall's prison-yard photo has had a woman's chest tattooed (for himself? for his lover? as a public service?) across his back.

In that moment, as bright as a camera flash, we were receiving encoded communications, though it would take us many years to decipher what we exactly were picking up through that buzzing swarm of boys. The messages were being transmitted by our little sister's new breasts, broadcasting their tender radar, their urgent, continuous signals from the still-hidden lives that awaited us, from our slowly emerging futures.

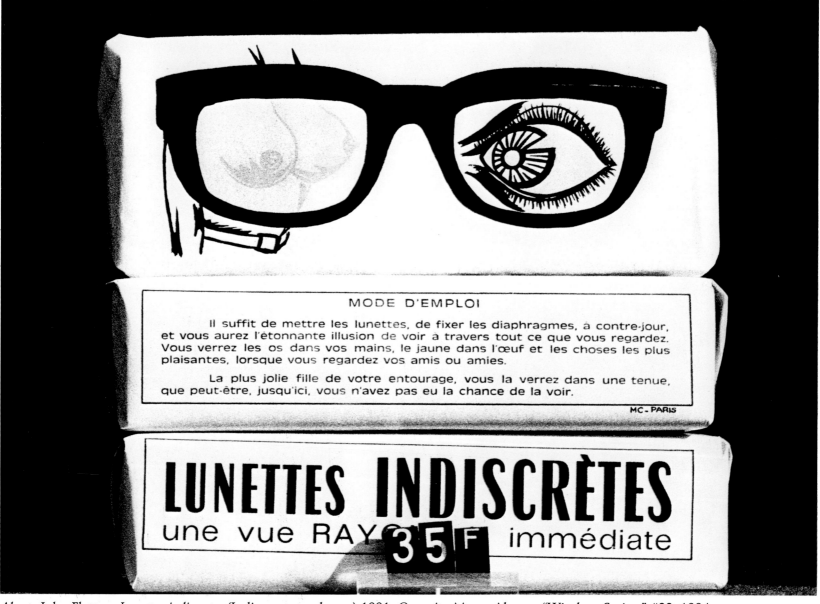

Above: John Flattau, *Lunettes indiscretes* (Indiscreet eyeglasses),1991; *Opposite*: Merry Alpern, "Window Series," #23, 1994

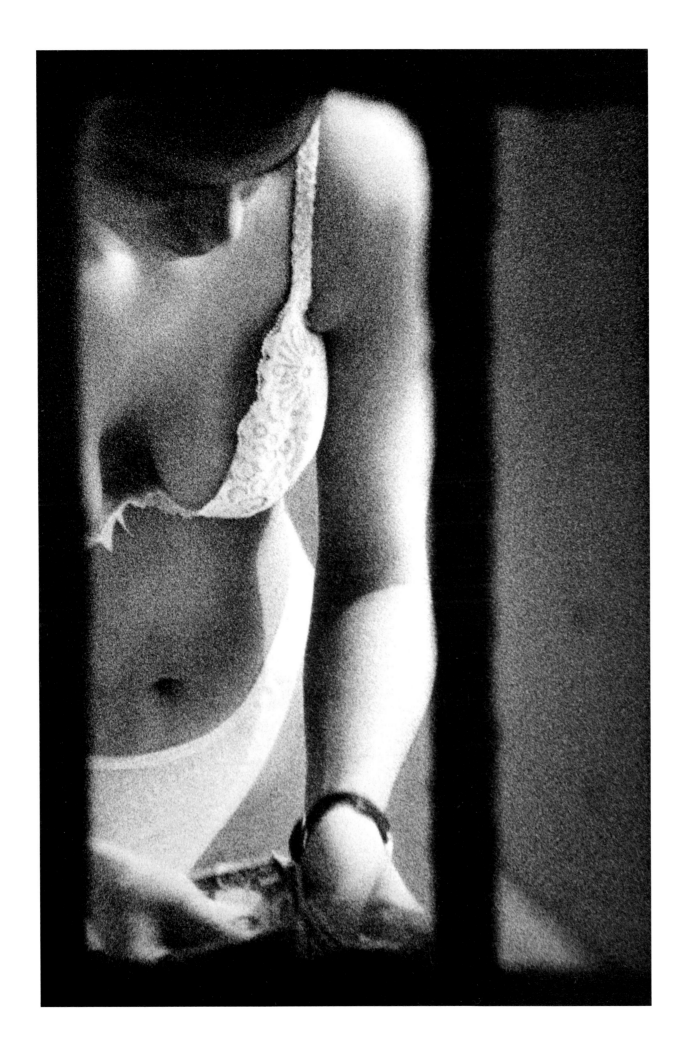

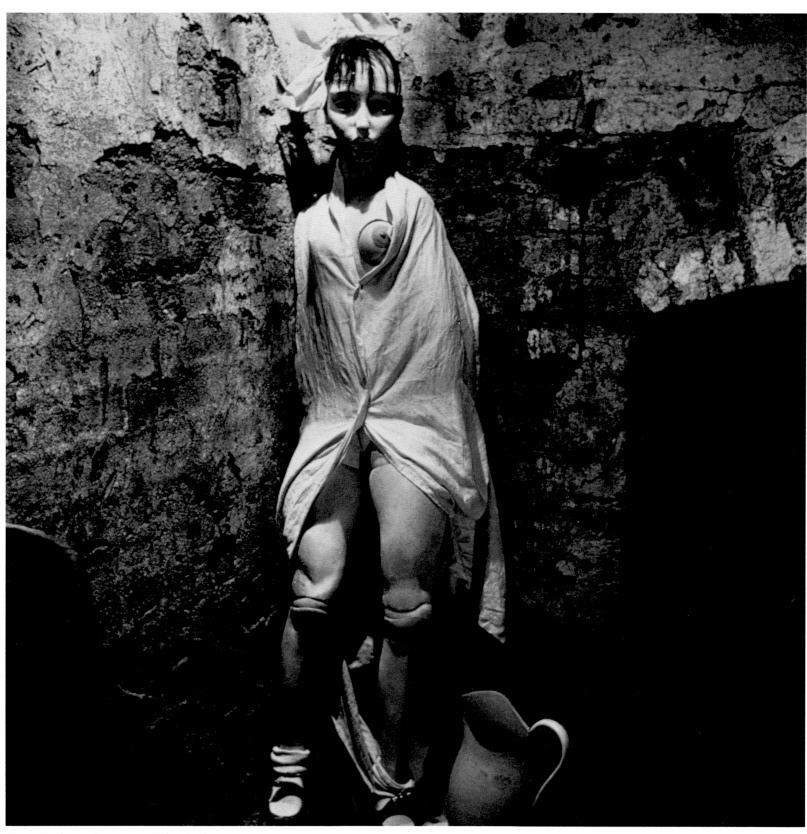

Hans Bellmer, *La poupée* (The doll), 1935

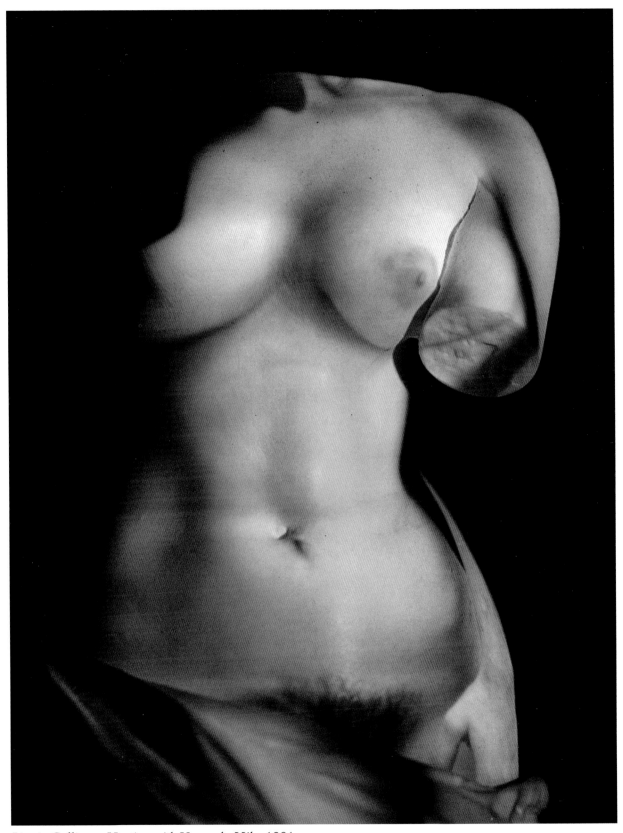

Lizzie Calligas, *Meeting with Venus de Milo*, 1991

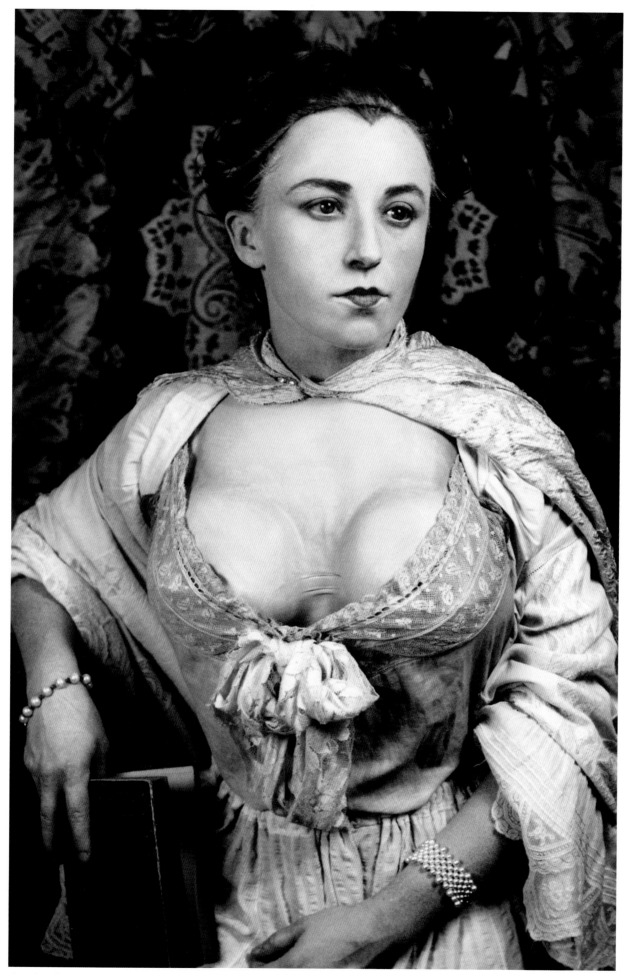

Cindy Sherman, *Untitled #183*, 1988

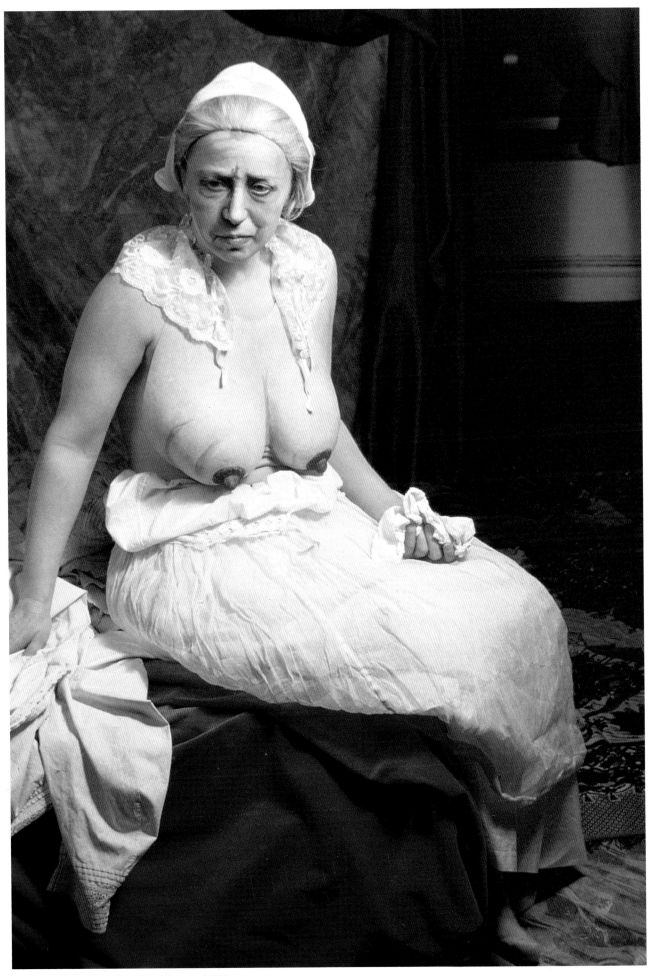

Cindy Sherman, *Untitled #222*, 1990

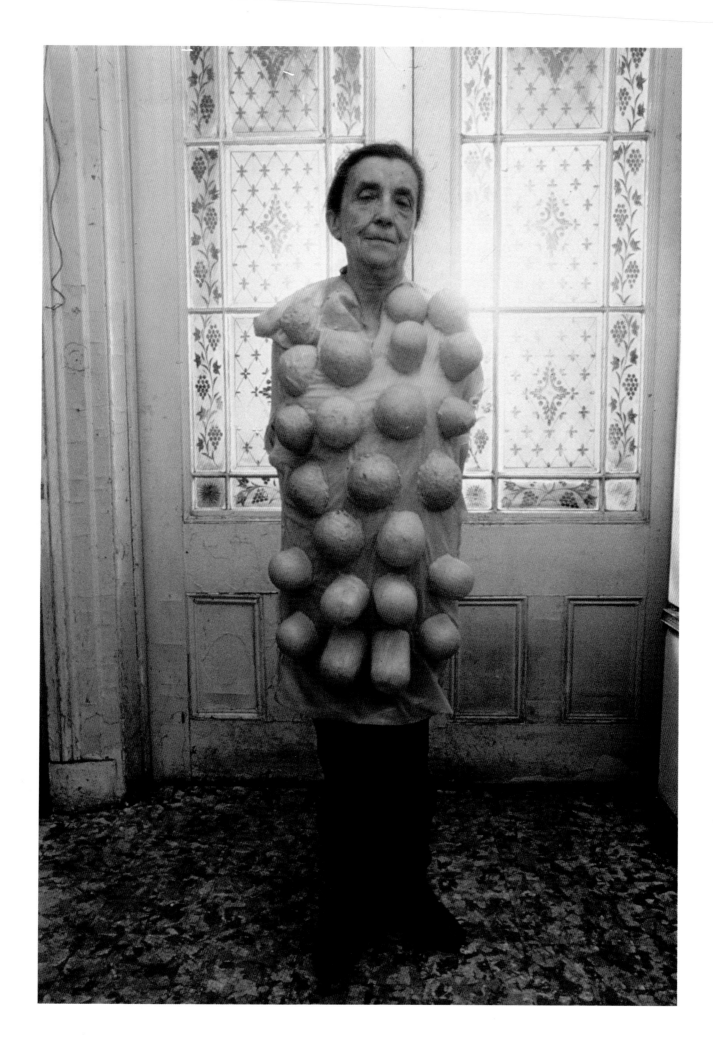

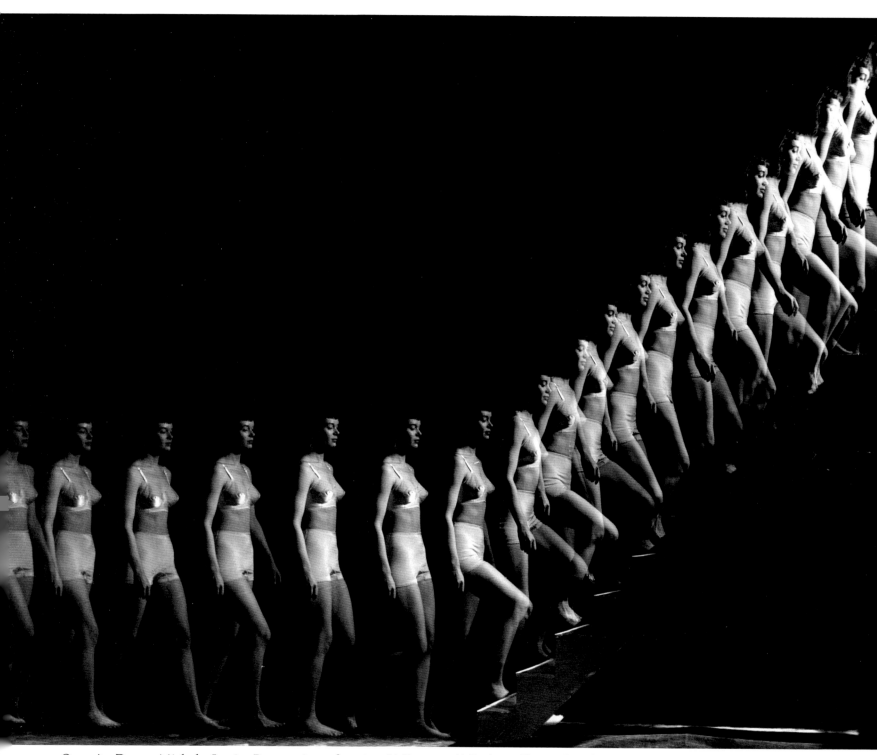

Opposite: Duane Michals, Louise Bourgeois performing "A Banquet/A Fashion Show of Body Parts," 1980
Above: Ralph Bartholomew, Playtex woman walking up stairs (for *Harper's Bazaar*), 1948

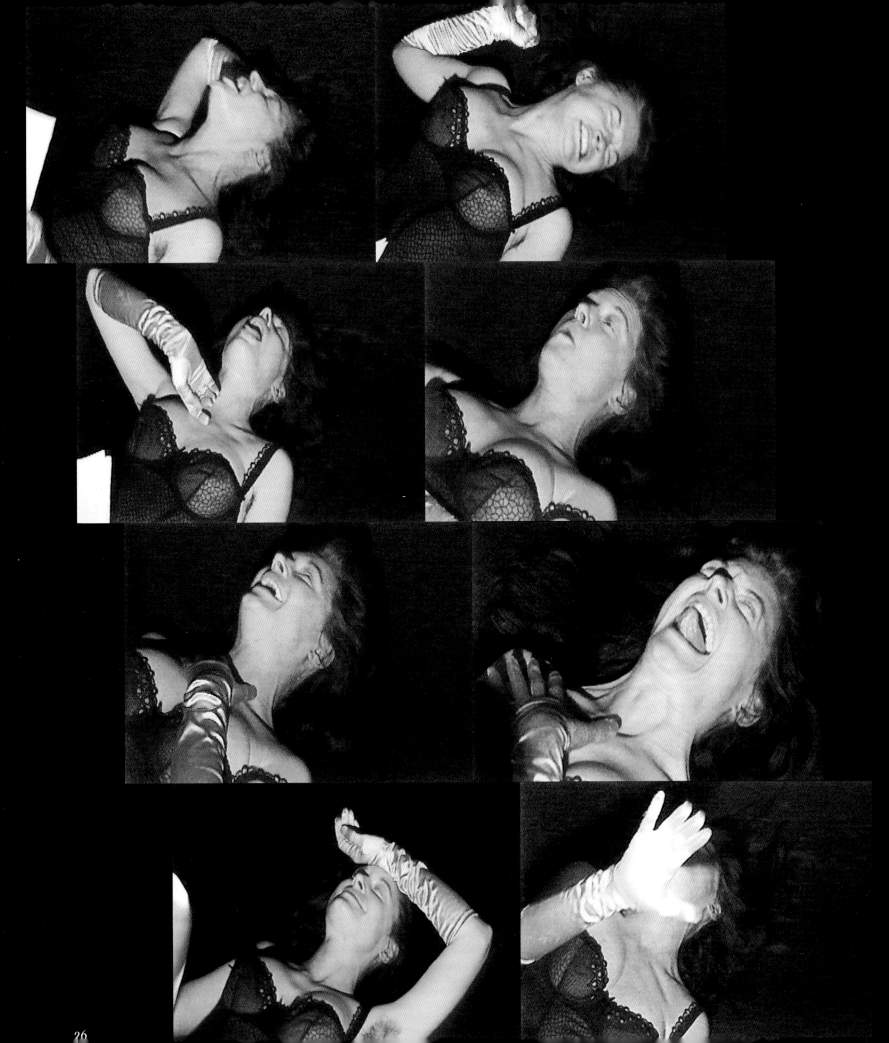

THE DETECTIVE

BY KAREN FINLEY

When Nicky walked out of the library to go to lunch she knew it would be difficult to be taken seriously, to be left alone.

Baby, I like those titties. Baby, I like your ass. Come on over here Mama.
Kiss Kiss Kiss Kiss.
Come here pussy puss puss puss.

Lady, bitch I'm flattering you!

This is the reason why when Nicky walked outside she was so concerned about her image. She never wanted to be looked at as Pussy Galore–one of James Bond's girls. She wondered where they were now, the actresses.

Nicky was in the diner deep in thought when she spoke out aloud, "Why couldn't James Bond show his bulge, his ass crack cleavage?"

Everyone in the diner looked at her and Nicky spilled her orange juice all over her chest. A male detective rushed over and began wiping her vest with a napkin. "Let me help clean you up. This is my special area of expertise." HA HA HA HA HA HA HA.

Nicky kept this moment in mind.
Humor and humiliation are very similar.

Later that night she would dream of James Bond wearing pants exposing his cheeks or wrapping his privates,

pushing up his genitalia, squeezing together his testicles, formfitting his wrapped penis in lace, in polka-dotted swiss, zippers huge and shiny, exposed to tight fitting contraptions with snaps and cup sizes.

Men's clothes need to be eroticized.
I want to see men's nipples. I want to see men photographed so we can see the tips of their nipples, hard and erect, on the cover of TIME. I want little see-through panels across their chests.

I want clothing that grabs attention to a man's scrotum. I want testicles dressed in nice, wooly caps. I want the hot, hairy ball look. I want high-heeled Oxfords and Nikes so the butt goes up in the air, so I can grab booty.
I want to smell booty.
I want to see the penis in
A CONSTANT STATE OF ERECTION.
And I want that interpreted by fashion NOW. And if that means banana, salami appliques sewn on the crotch, OR the wiener actually taken out of its confines of the trouser mandate, then dressed in haute couture, then I'm ready for it!
And in the same way that women's suits have the mandatory shoulder pads, giving the feeling of access to big shoulder male power, the male should wear falsies sewn into his work shirt to give the illusion of nurturing, adaptability, and the right to be humiliated.

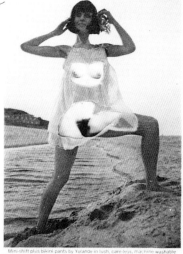
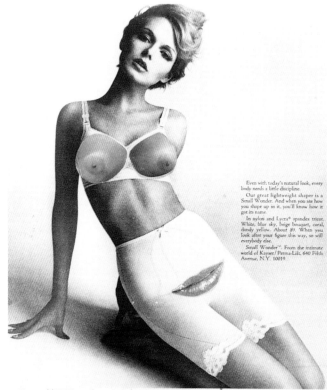
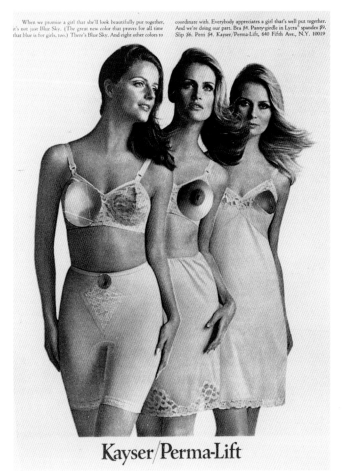
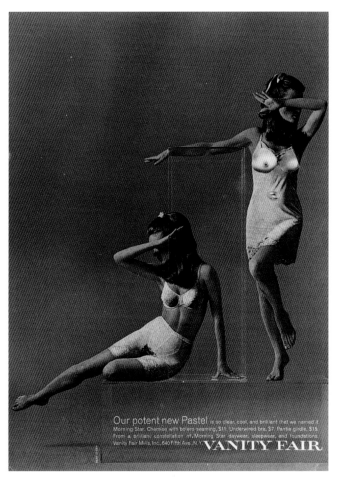
28

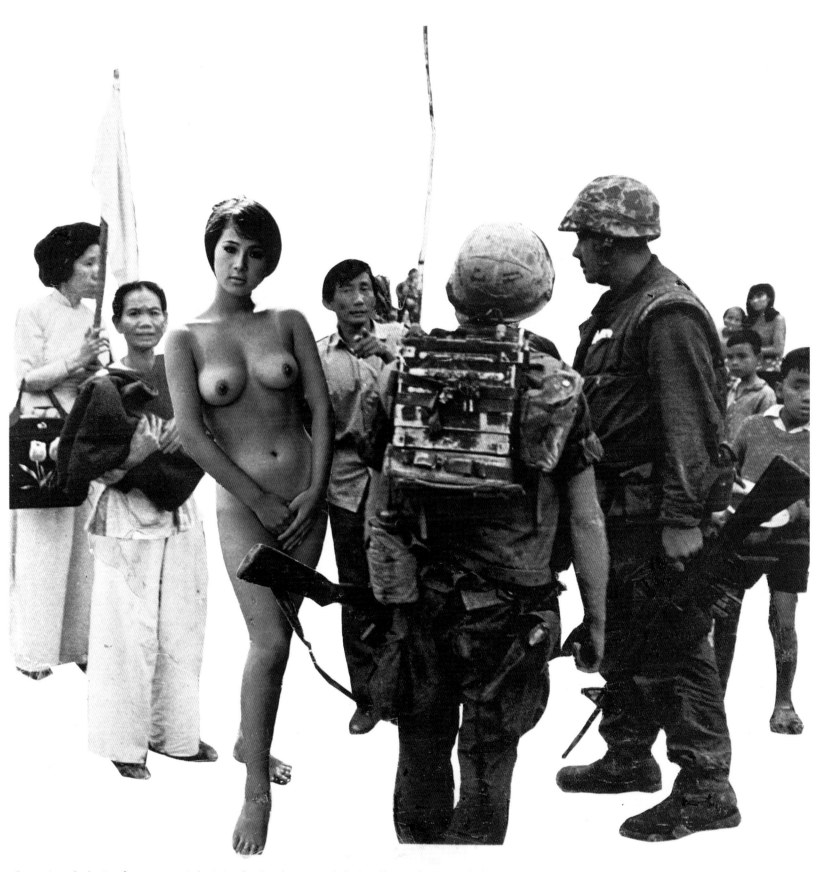

Opposite, clockwise from upper right: Martha Rosler, *Untitled (Small Wonder)*, *Untitled (Transparent Box)*, *Untitled (S,M,L)*, *Untitled (Baby Dolls)*, all from the series "Body Beautiful (Beauty Knows No Pain)," ca. 1966–72
Above: Martha Rosler, *Playboy (On View)*, from the series "Bringing the War Home: In Vietnam," 1969–72

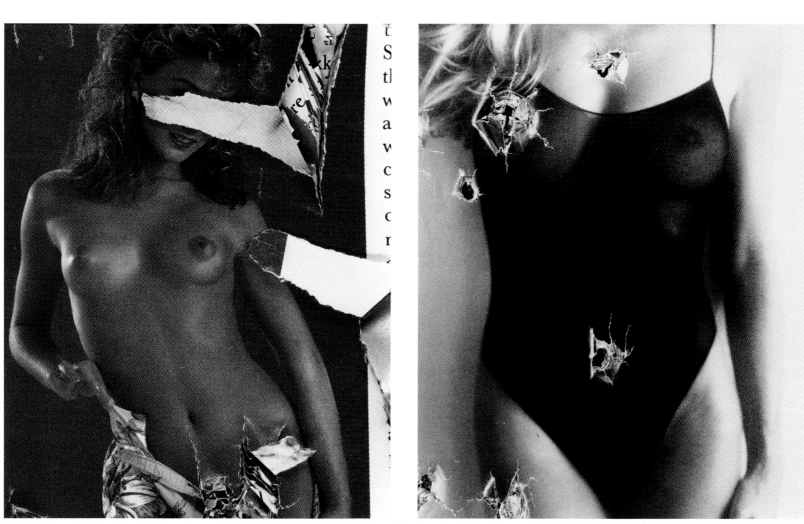

Left: Richard Misrach, *Playboy #140 (Safety Shorts Condom Pouch)*, 1990; *Right*: Richard Misrach, *Playboy #169 (Vanna White)*, 1991

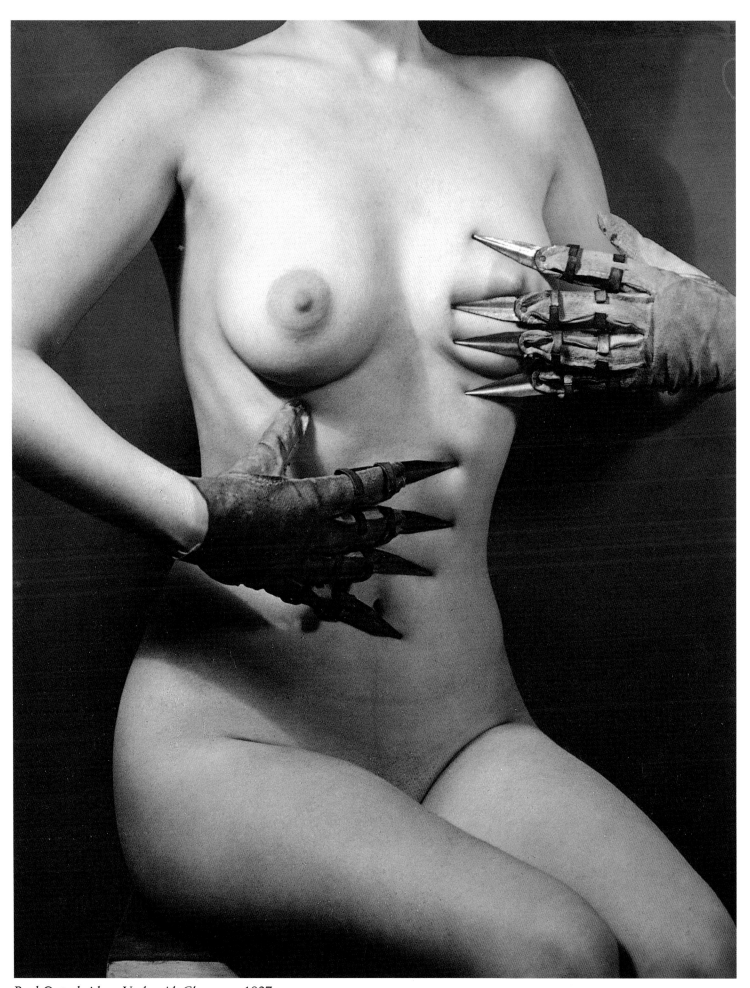

Paul Outerbridge, *Nude with Claws*, ca. 1937

Nobuyoshi Araki, untitled, 1991

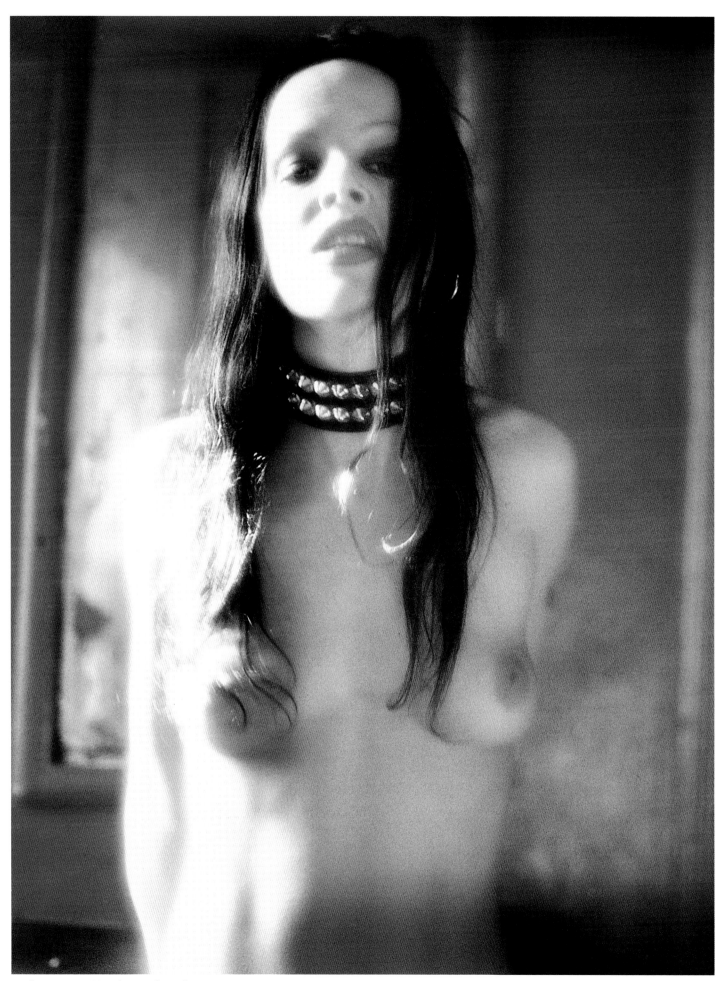

Jack Pierson, *Kembra with Collar*, 1993

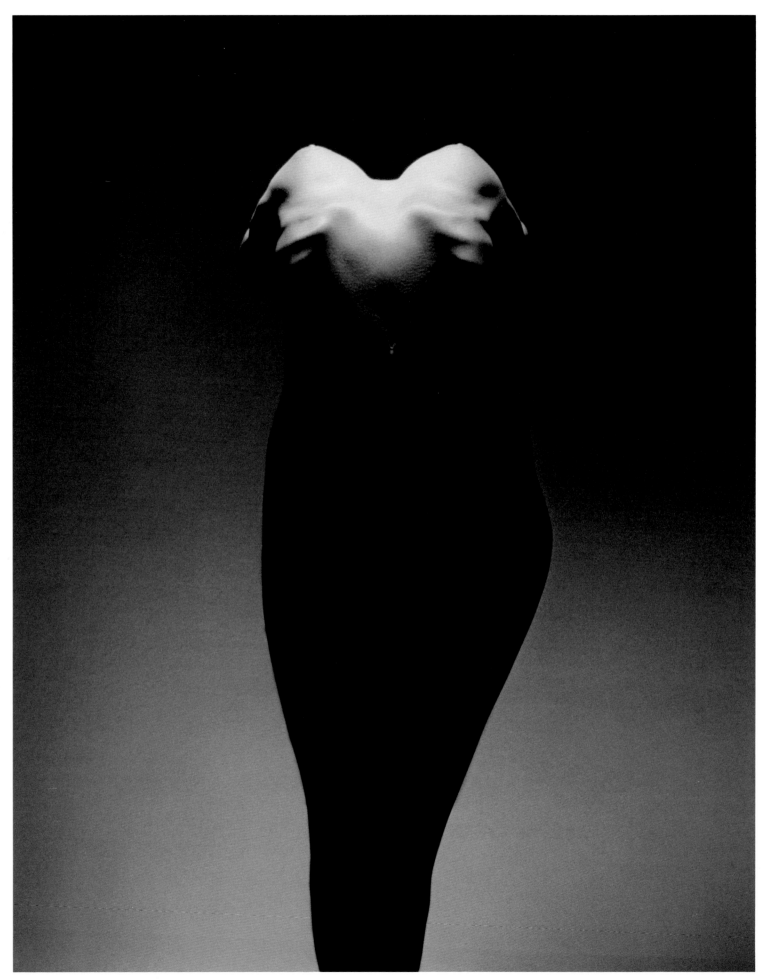

Tono Stano, *Pohádková figura* (Fairytale creature), 1995

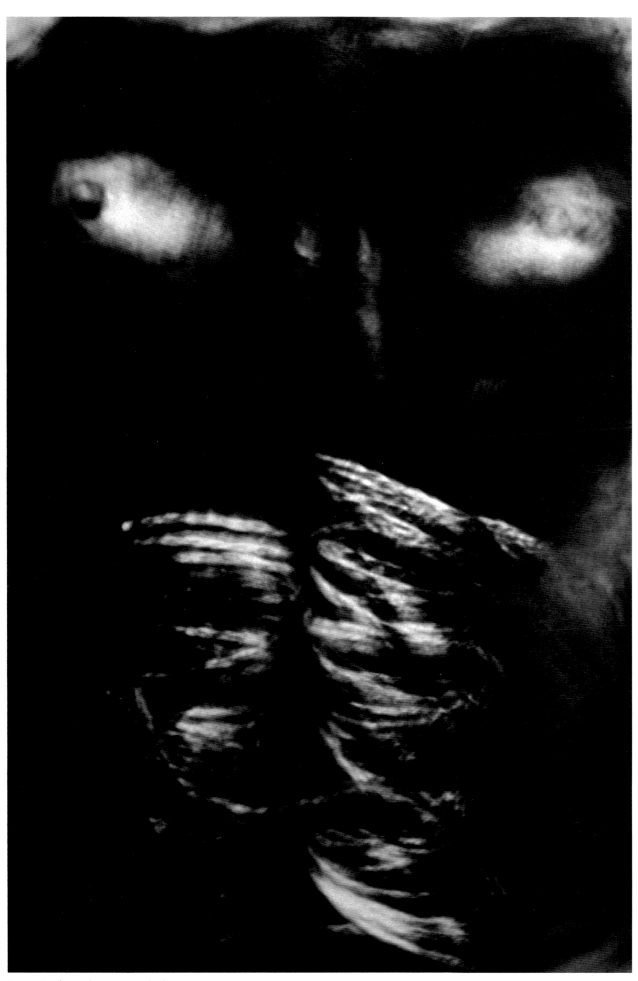

Juan Carlos Alom, untitled, 1995

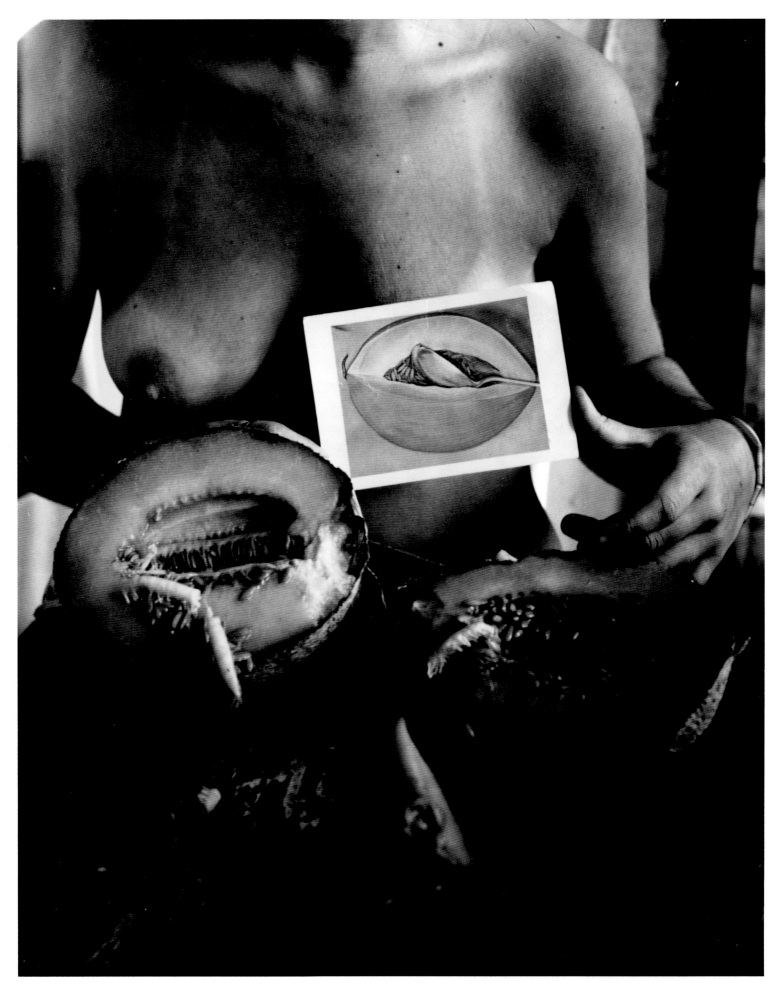

Opposite: Francesca Woodman, from the series "Three Kinds of Melon in Four Kinds of Light," Providence, 1975
Above: Francesca Woodman, *On Being an Angel*, Providence, 1977

Eugene Richards, Sutured incision after the breast biopsy, 1988

I stand in front of the bedroom mirror and hold my hand over my left breast covering the nipple. I try to imagine what it would look like. "What are you doing?" Gene asks.

I decide to go ahead with surgery. Treatments with radiation would mean sitting beneath an X-ray machine day after day, waiting for the tumor to shrink, dry up, die. It seems the way to get rid of this cancer is to cut it out from my body. I want to get rid of it quick, quick.

Tonight I cannot sleep. I am obsessed with when that one different voracious cell in my breast first exploded into life. The books say tumors can grow for years before they are detectable to the touch. So I can't help wondering if it was already in place that night we skinny-dipped at Sunset Lake, or when I covered my first news story, or that summer I spent trying to run more than a mile.

Gene lies beside me, restless, wanting sex. How could anyone be attracted to me right now, with my oozing, discolored breasts and my frozen thoughts? I wish I could explain to him that it isn't just the loss of a breast that's troubling me. It is what the loss symbolizes, a premonition of the day when all the cells in my body are extinguished like cold stars.

—Dorothea Lynch

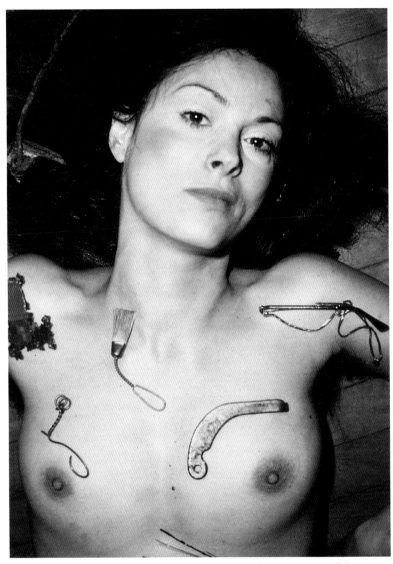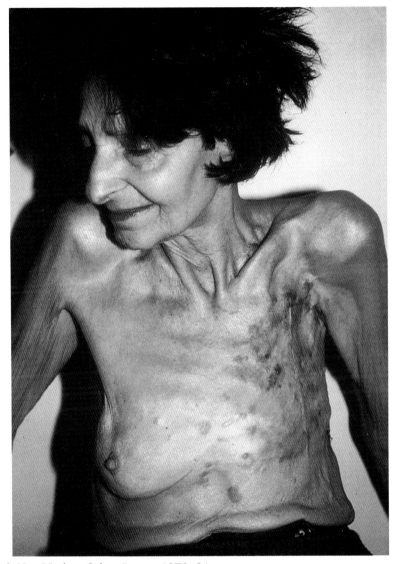

Hannah Wilke, *Portrait of the Artist with Her Mother, Selma Butter,* 1978–81

Nudity, like death, is an extreme, and that's one reason it is important to expose its truths and ambiguities....

I seduced [my mother] into allowing me to be with her during her battle with cancer. My going to the hospital and sitting with her nine hours a day made her feel guilty. So in order to absolve herself, she let me take the photographs, because then, somehow, I was still doing my art. I don't think she would have been embarrassed....

When I did nude photographs of me dying called "So Help Me Hannah" theatricalizing all of my problems of

losing and feeling with all of the problems and pain people have experienced in my lifetime in Germany, in Vietnam, in Cambodia, in El Salvador, all the real issues in war including its perverted sexuality.... I sort of got out of my own problems and thought about the pictures of war.

I think my mother did this too....

Often when she was sitting in a great deal of pain and she'd see me take out the camera, she held her feelings for the photograph not disguising her pathos.

—Hannah Wilke

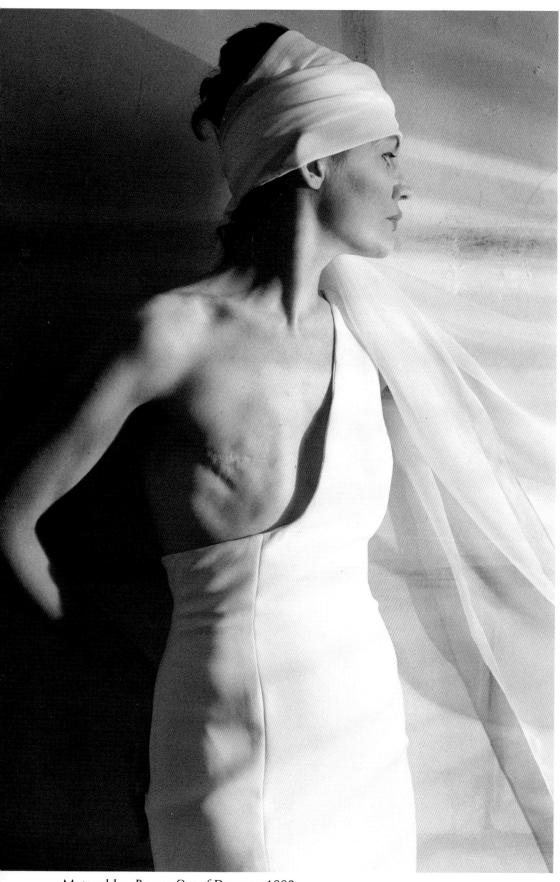

Matuschka, *Beauty Out of Damage*, 1993

My life changed drastically in 1991 when I was diagnosed with breast cancer, and had a mastectomy. My experiences with the medical profession and social interactions around my illness were extraordinarily disturbing. My response was to investigate, learn, and speak out. Simultaneously, I was challenged to continue self-portraiture, as it obviously meant a very direct confrontation with the process I was undergoing. I found that while I was up to making the images, no one was up to viewing them, despite the fact that they were basically visually attractive celebrations of survival. The reaction of society to me as an "asymmetrical woman"... provided more grist for the mill.

Peter Schlessinger wrote about my work in this way:
"The idealized female body is simultaneously an object of adoration and abuse in our modern male-defined world, and breasts—preferably large, symmetrical, unsuckled and gravity-defying—have become the centerpiece of that idealization. Because breast cancer treatment often involves the partial or total removal of that centerpiece, it is a far more volatile subject than other disease or treatment effects. It is, in fact, a subject that unavoidably spirals into the question of what a woman is, and who has the right to define that."

A woman can still be beautiful and can wear her scars as a symbol of strength. —Matuschka

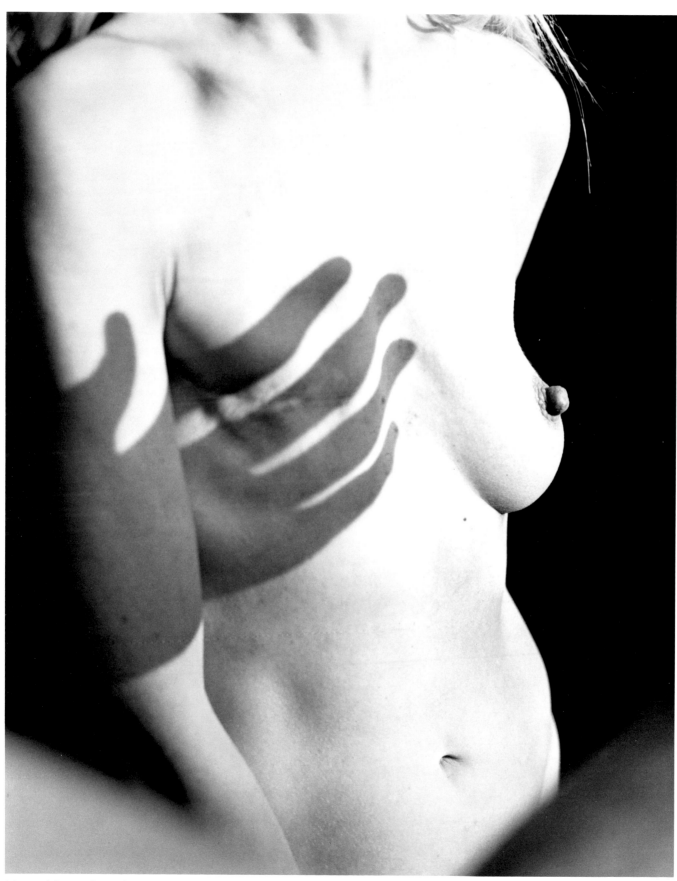

Matuschka and Mark Lyon, *The Hand*, 1992

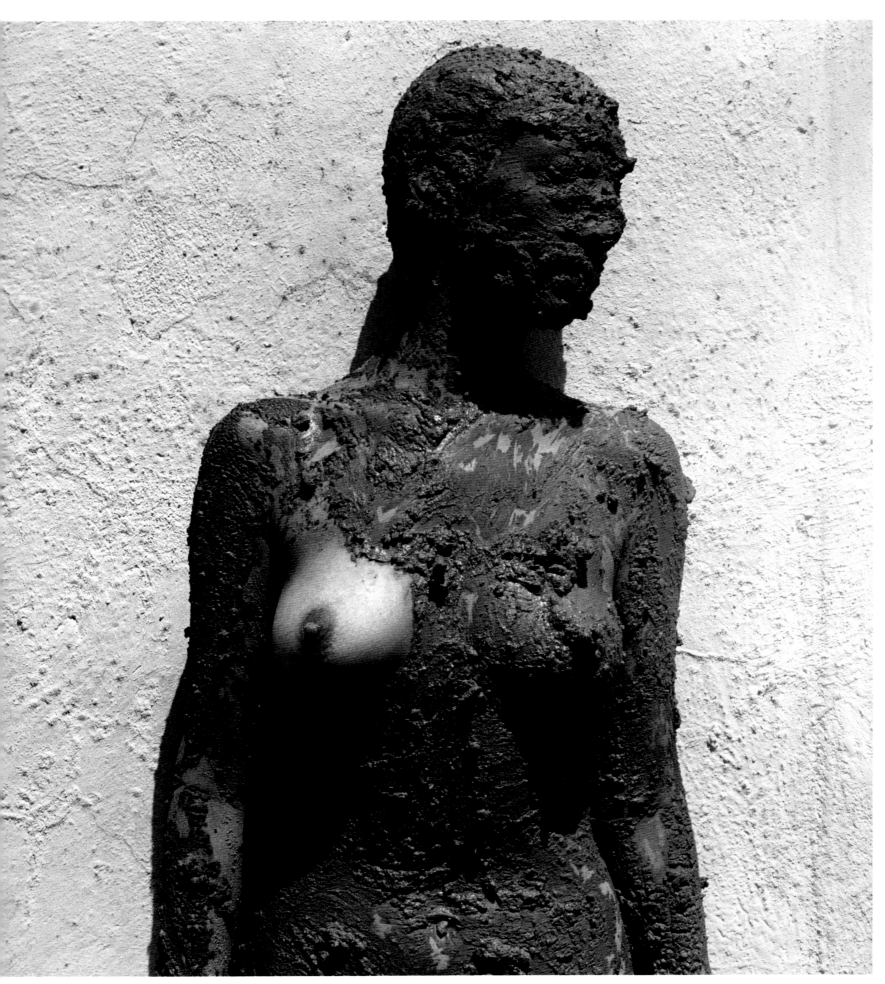

Eugenia Vargas, *Untitled*, 1987

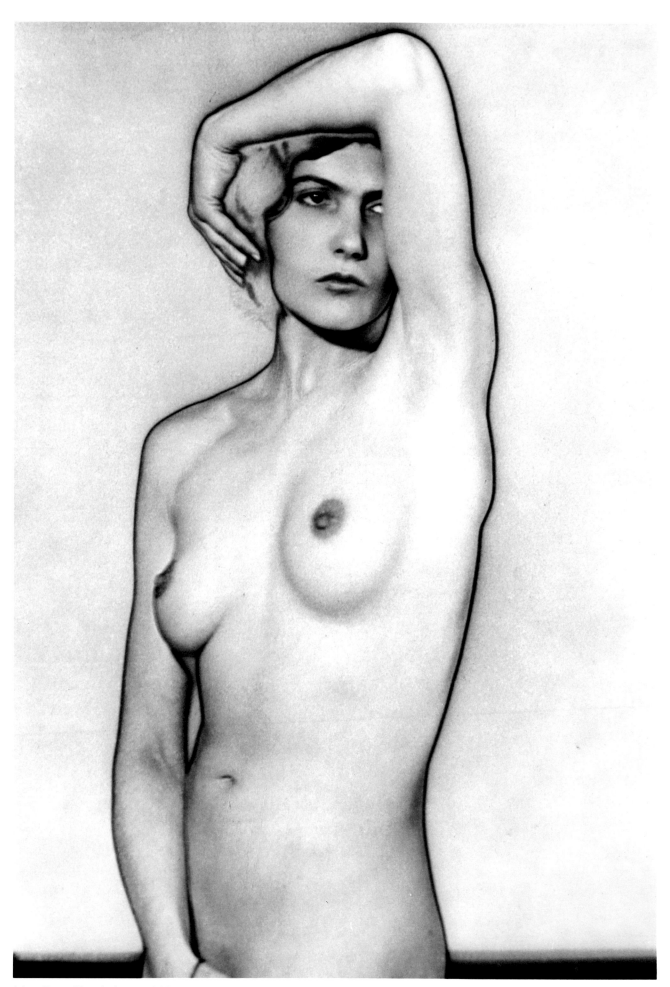

Man Ray, *Untitled*, ca. 1929

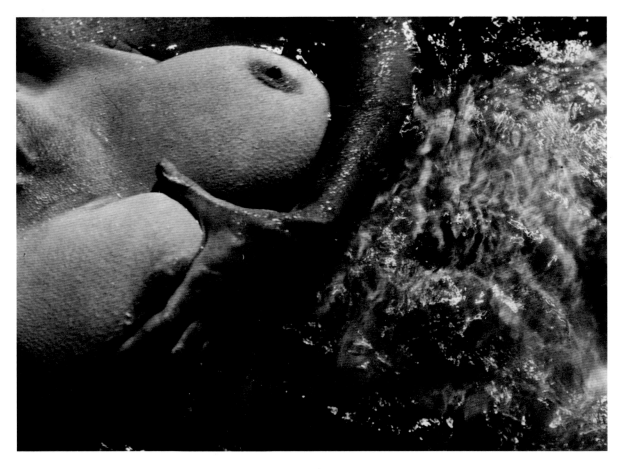

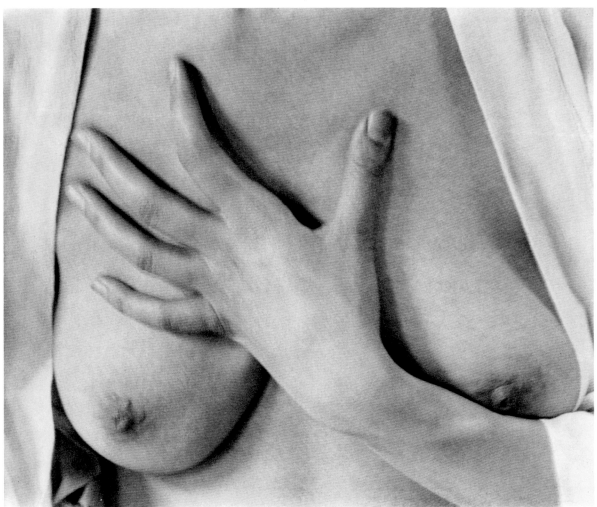

Top: Alfred Stieglitz, *Portrait of R.*, Lake George, 1923
Bottom: Alfred Stieglitz, *Breasts and Hand*, from the series "Georgia O'Keeffe," 1919

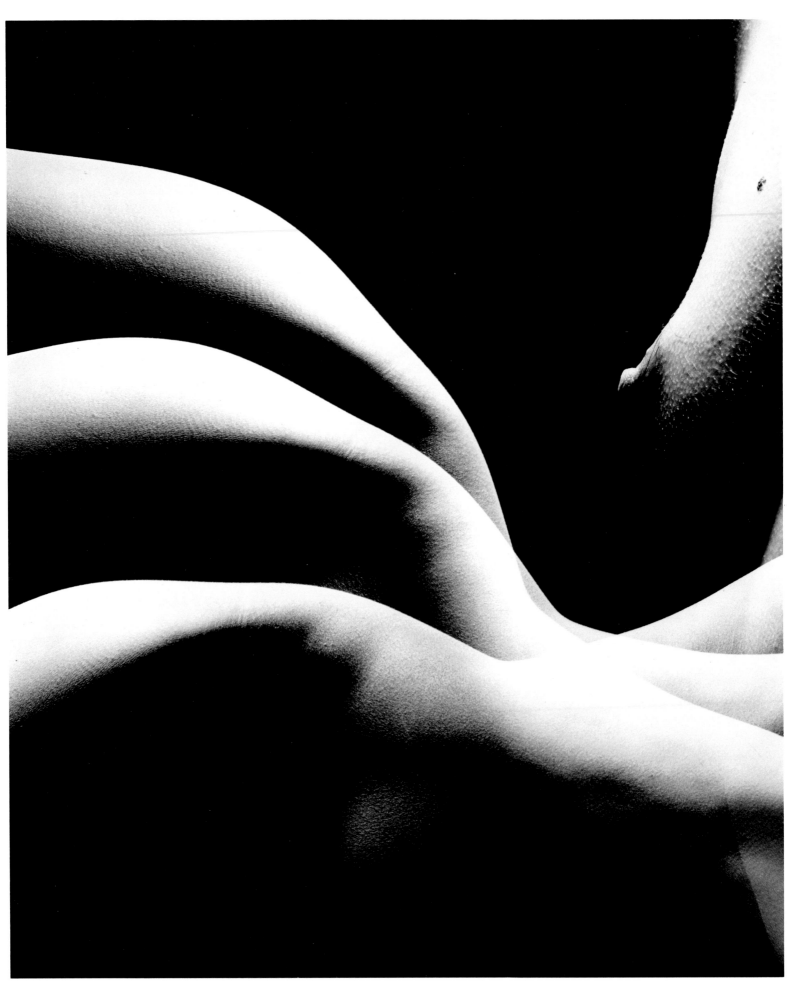

Jack Mitchell, *Female Nude 5040-1-12*, 1991

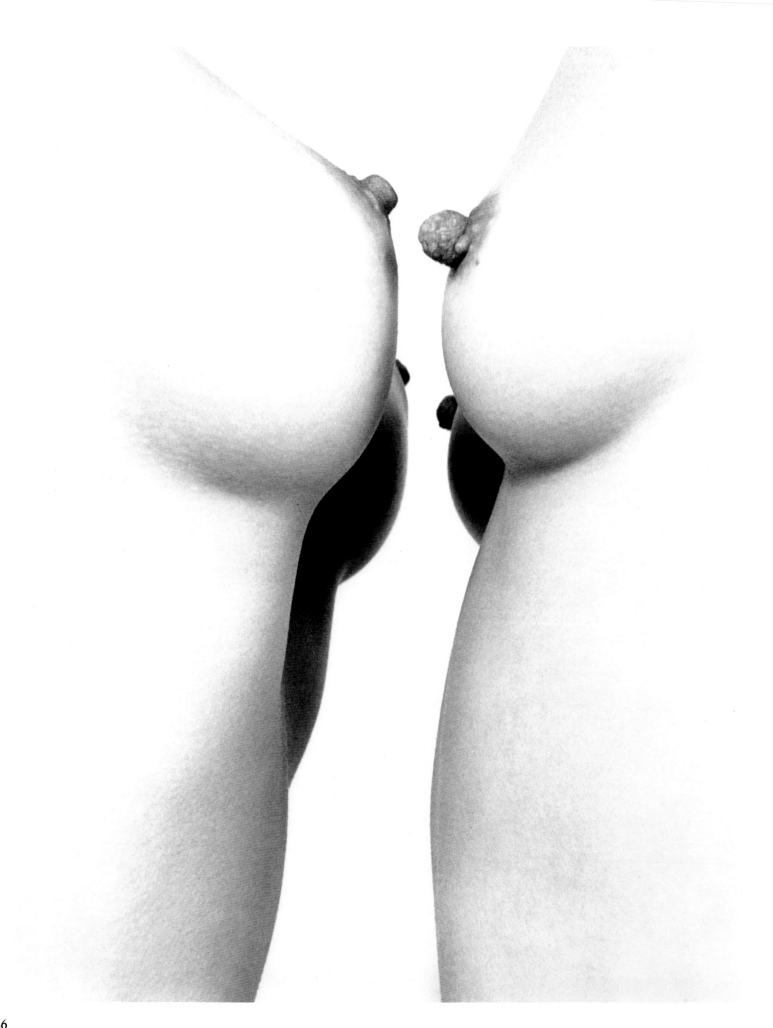

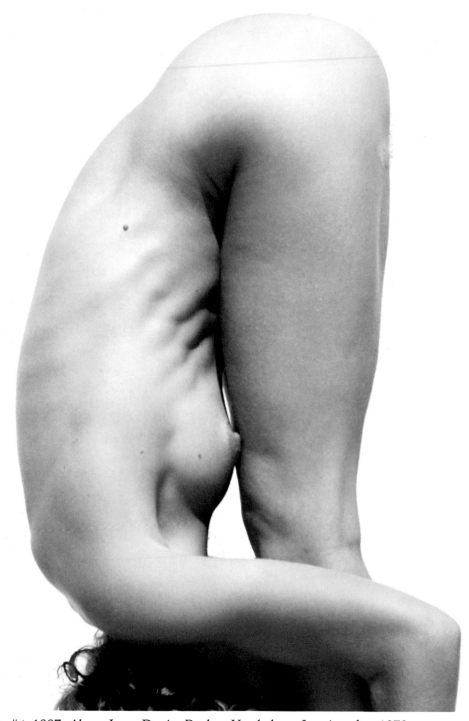

Opposite: Beth B, *Monuments #1*, 1997; *Above*: Lynn Davis, *Darlene Vanderhoop*, Los Angeles, 1978

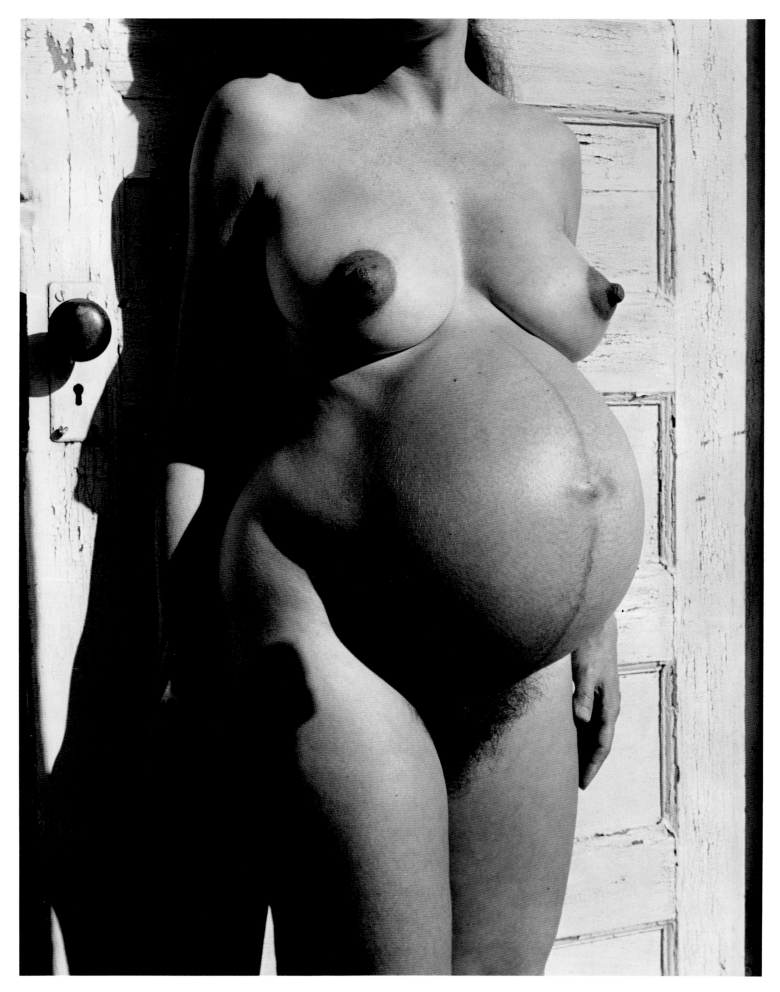

48

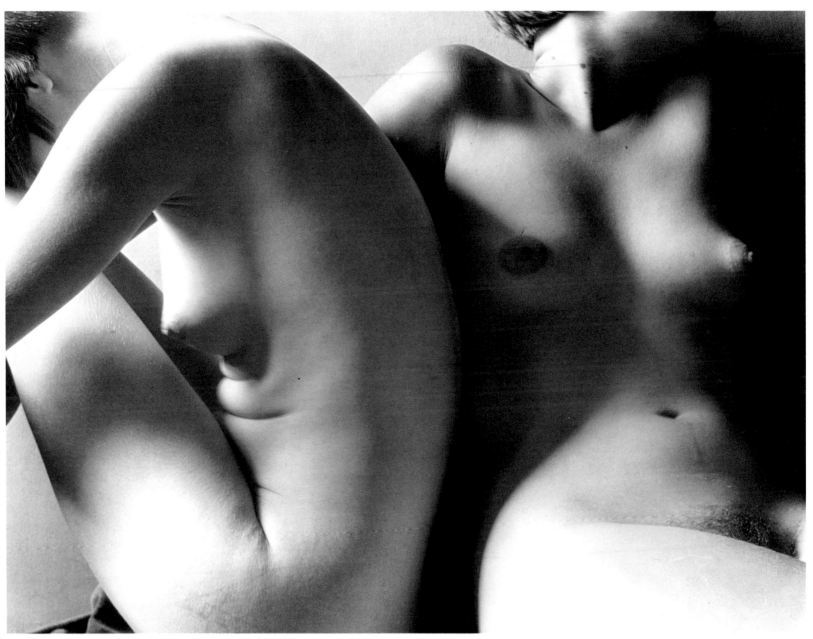

Opposite: Imogen Cunningham, *Pregnant Nude*, 1959; *Above*: Imogen Cunningham, *Two Sisters*, 1928

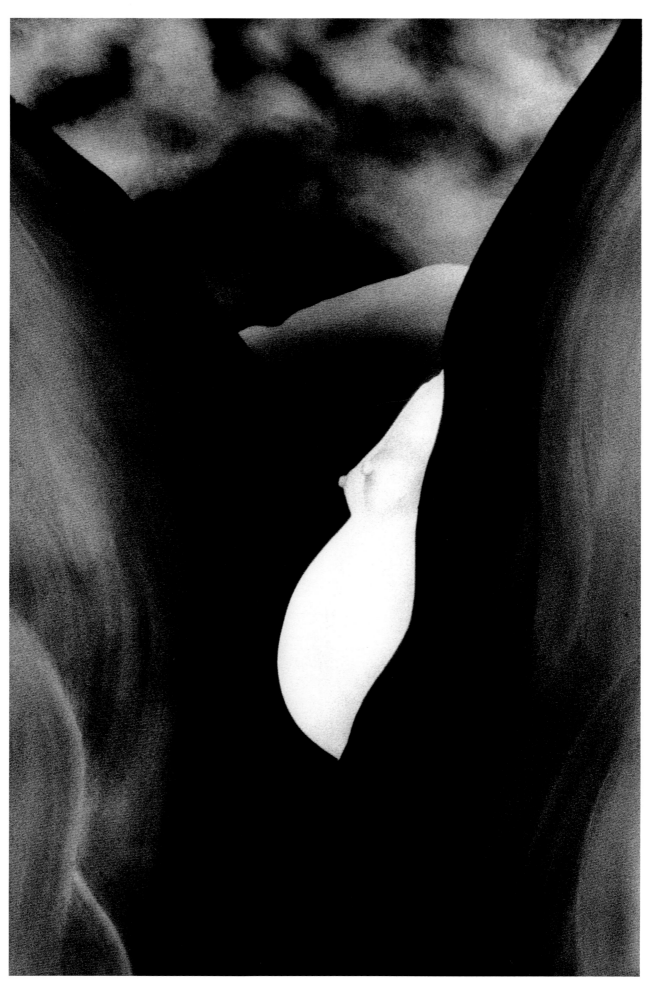

Lynn Bianchi, *The Birth of Mt. Pelion*, 1992

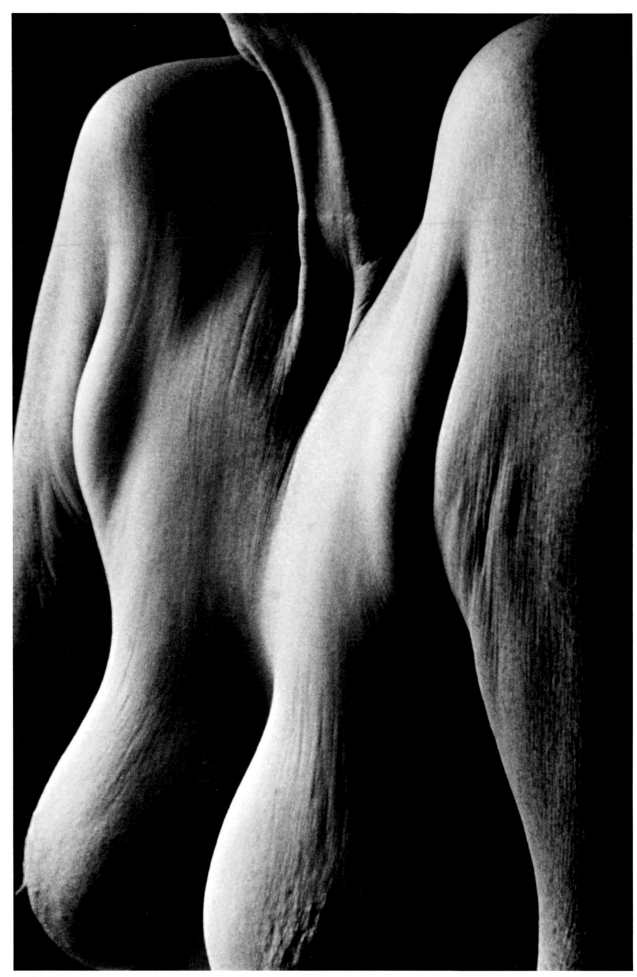

Yves Trémorin, *De cette femme* (About this woman), 1985–86

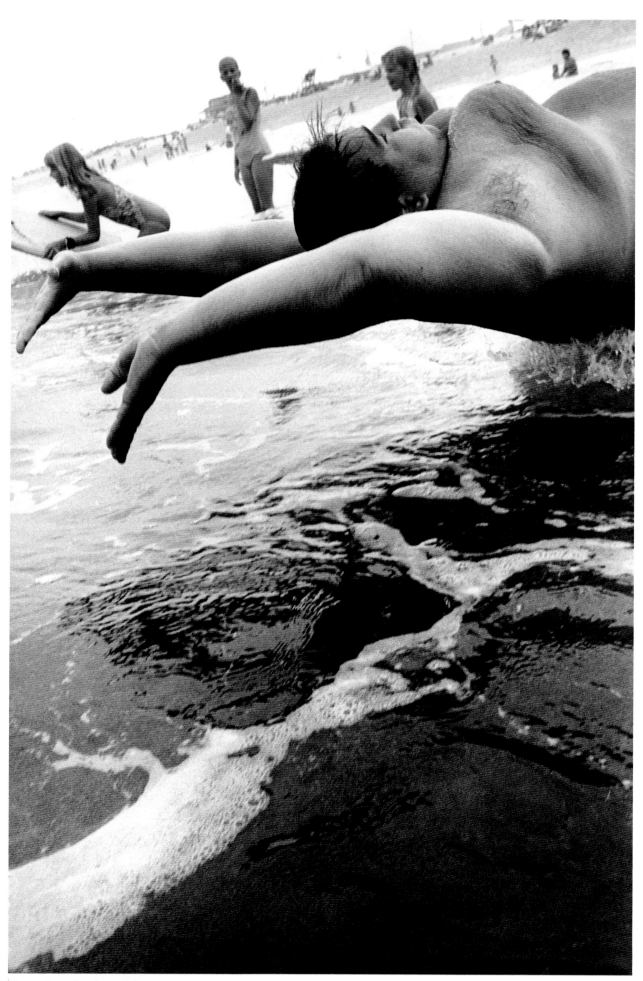

Kevin Funabashi, *Back Dive*, 1994

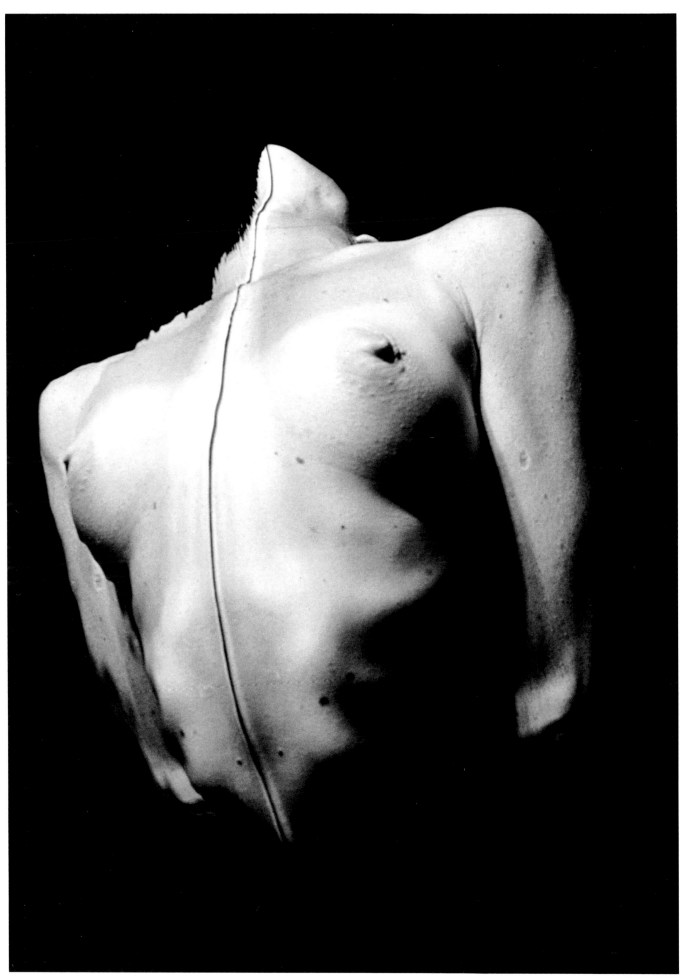

Connie Imboden, *Untitled*, 1996

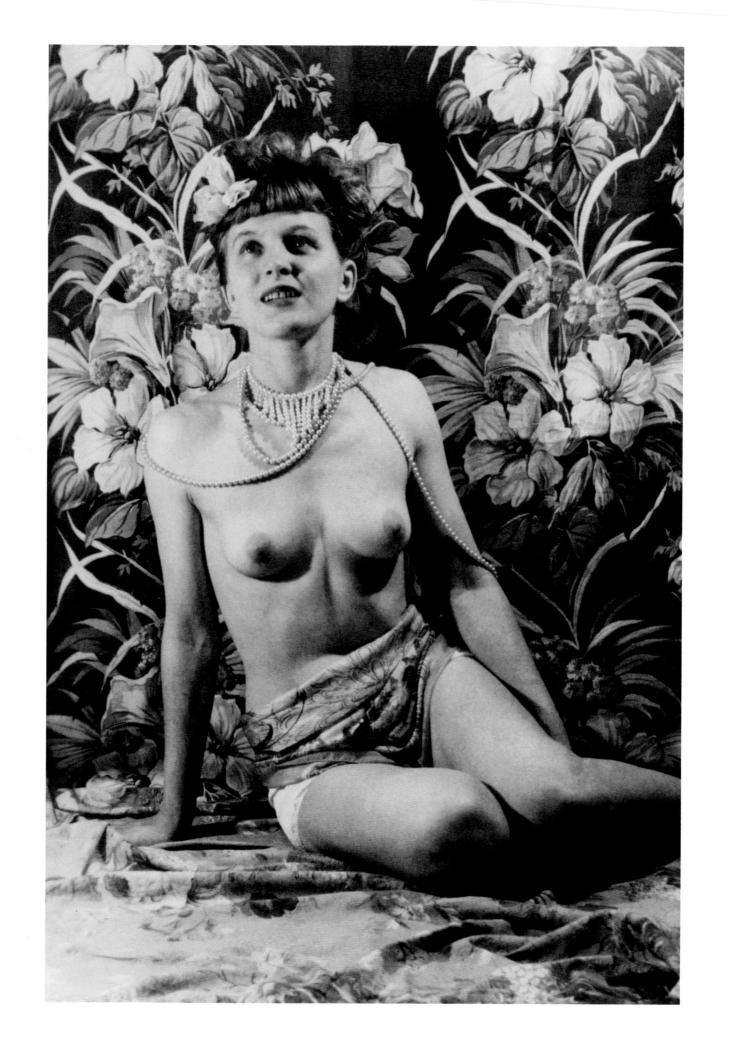

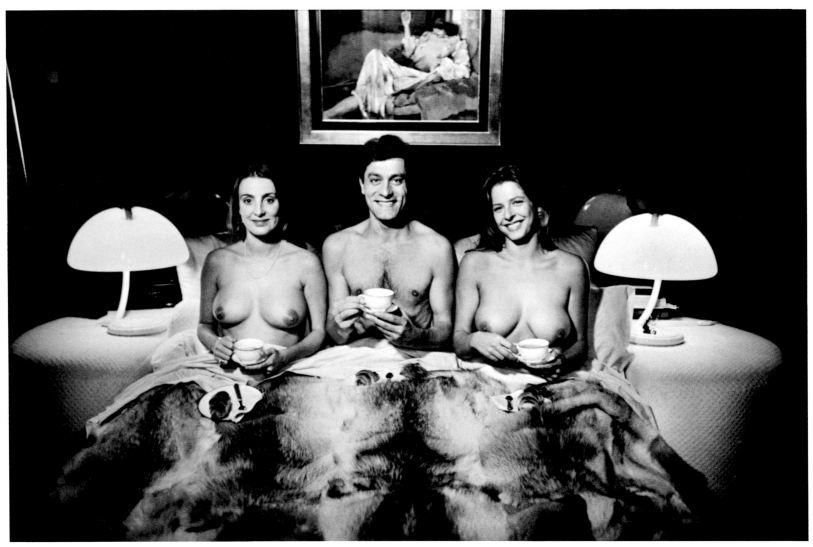

Opposite: Eugene von Bruenchenheim, untitled, ca. 1940s; *Above*: Elliott Erwitt, Paris, 1984

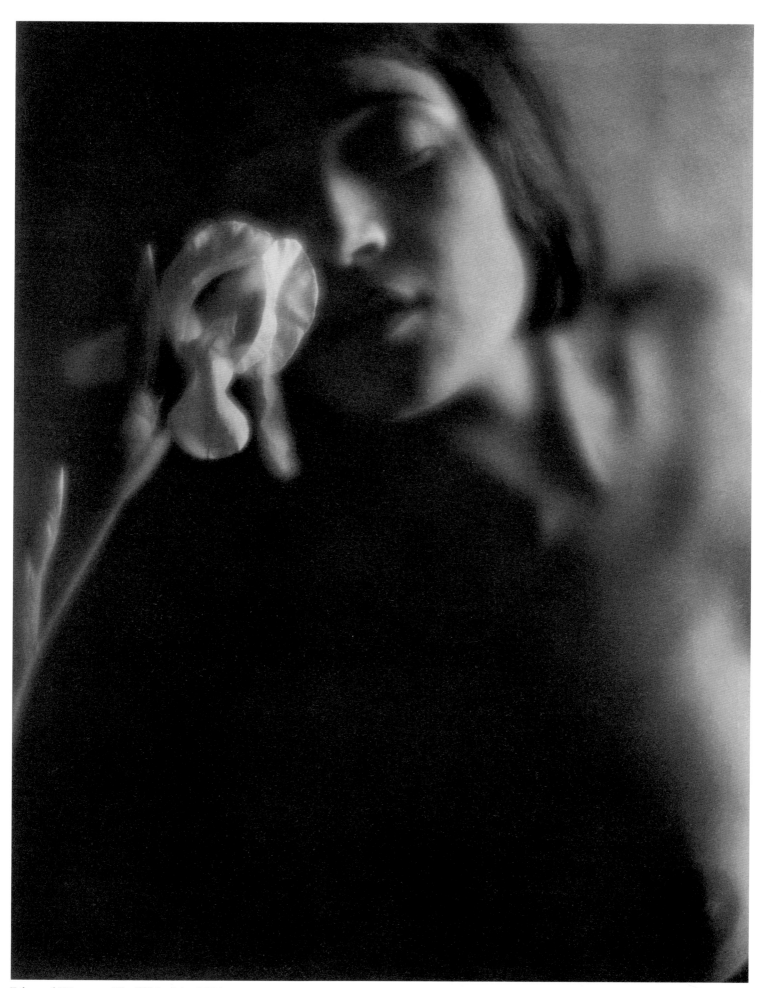

Edward Weston, *The White Iris*, 1921

Stephen D. Colhoun, *Lachende frau mit tasse* (Laughing woman with cup), 1955

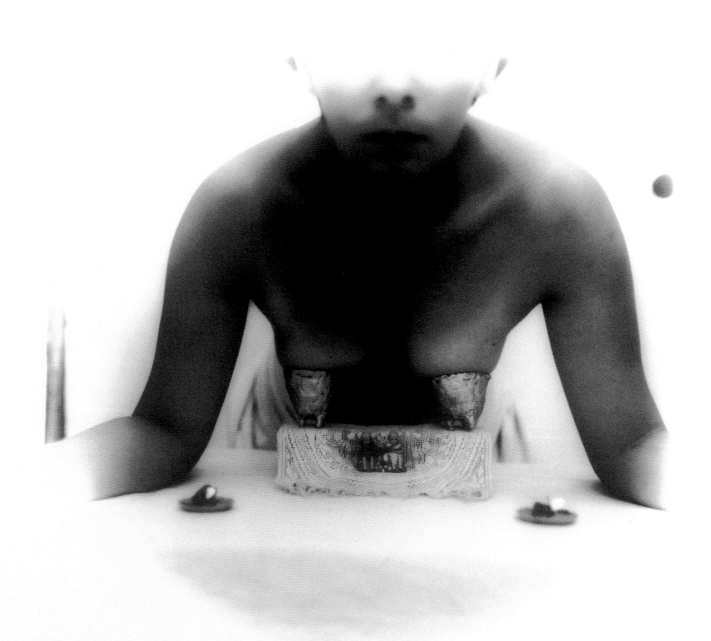

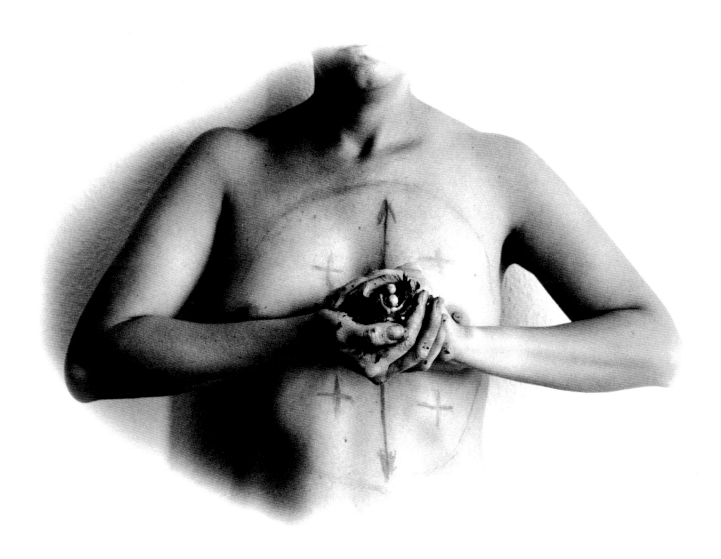

Opposite: Marta María Pérez, *Macuto*, 1992; *Above*: Marta María Pérez, *Cultos paralelos* (Parallel cults), 1990

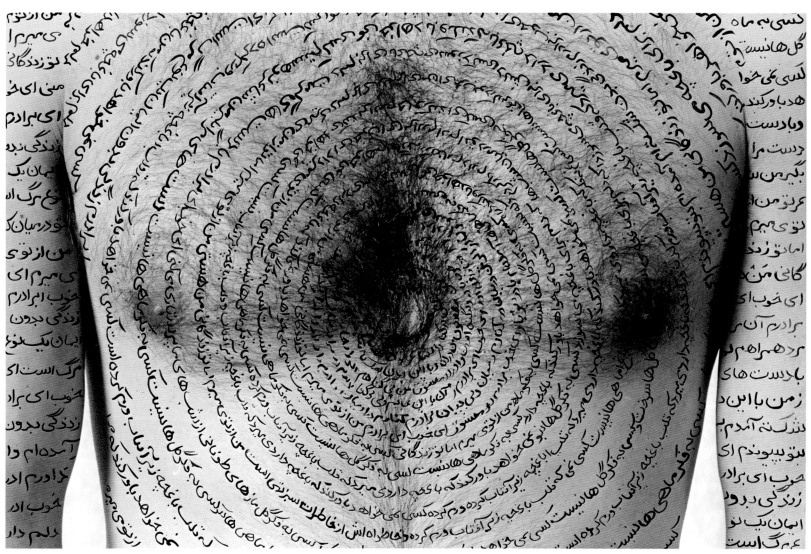

Shirin Neshat, *Careless*, 1997

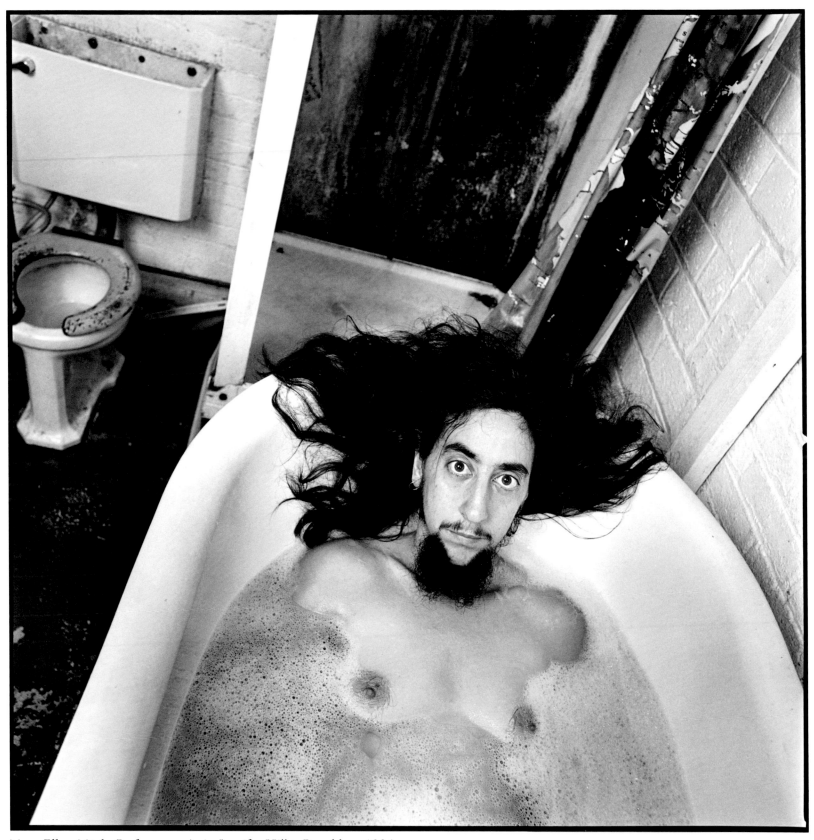

Mary Ellen Mark, *Performance Artist Jennifer Miller*, Brooklyn, 1994

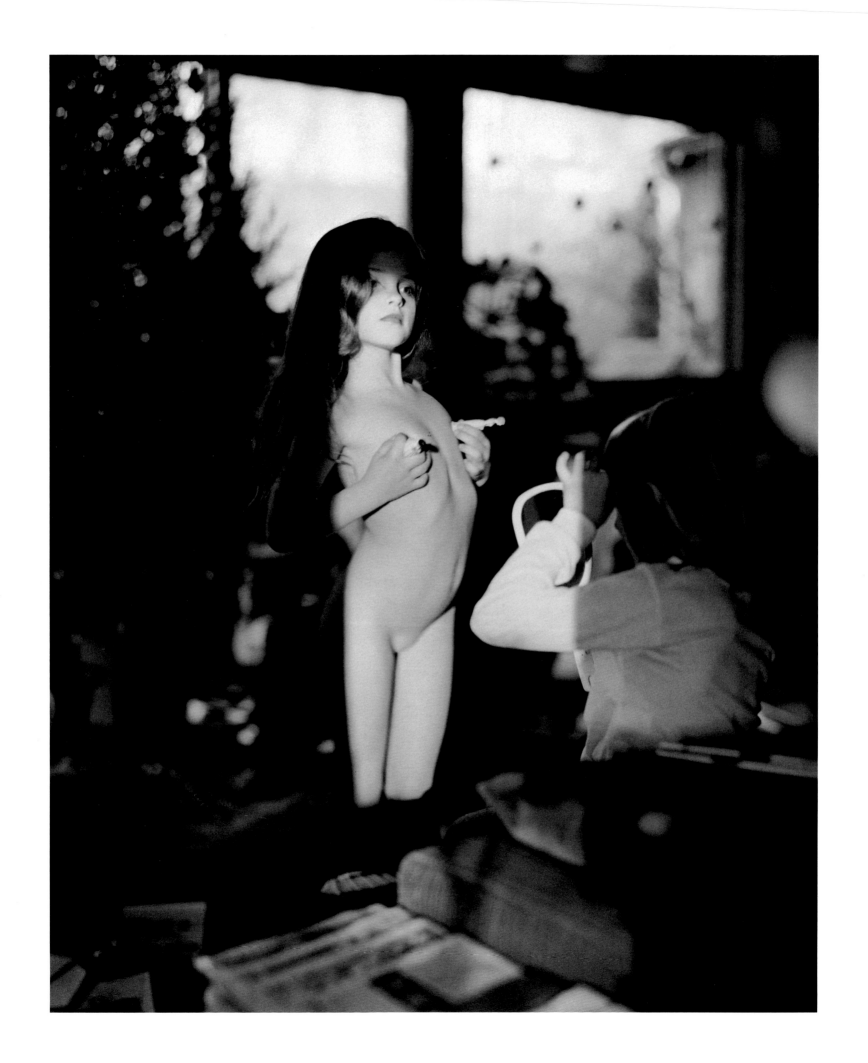

Opposite: Sally Mann, *Scarlett Nipples*, 1992; *Above*: Eugene Richards, *"Go Sam,"* Brooklyn, 1994

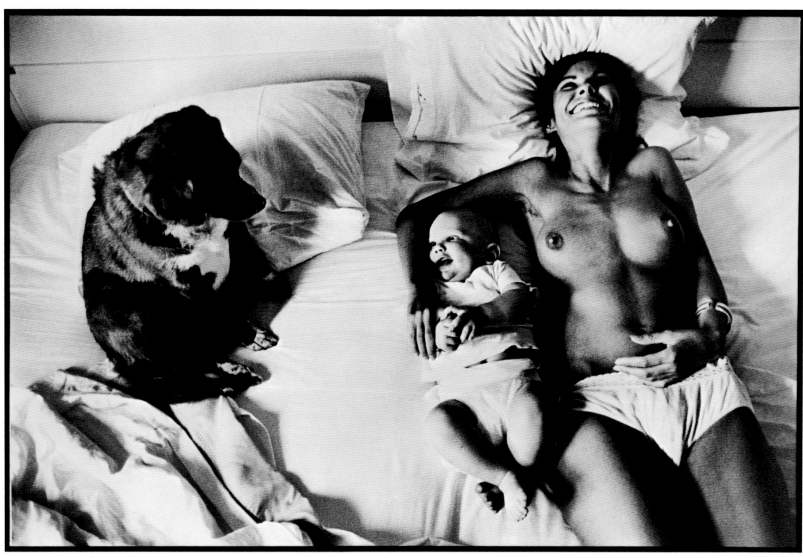

Above: Mary Ellen Mark, Los Angeles, 1974; *Opposite*: Eugene Richards, *Sam*, 1988

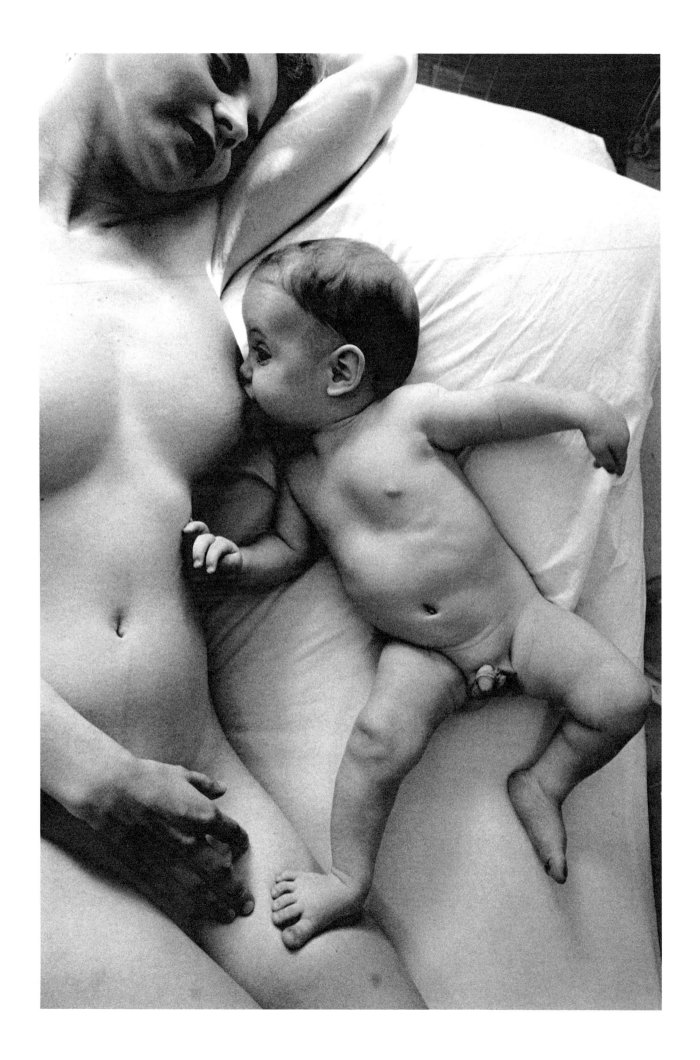

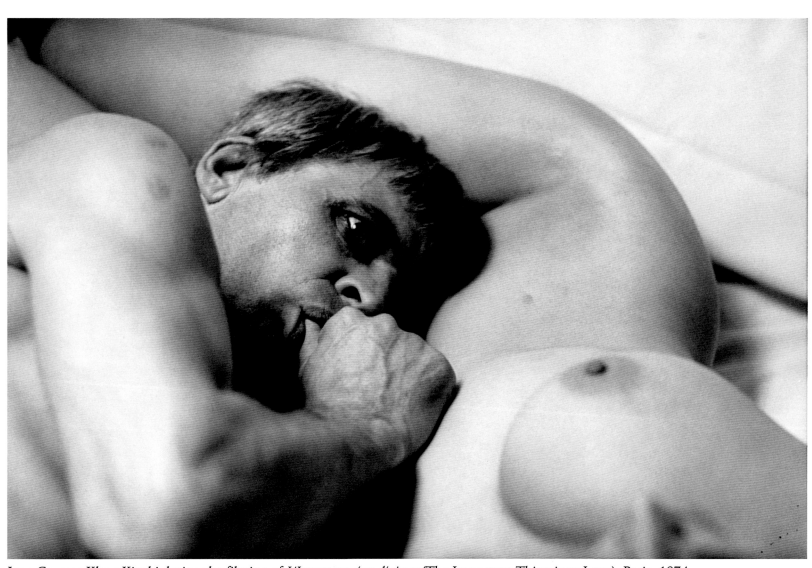

Jean Gaumy, Klaus Kinski during the filming of *L'Important c'est d'aimer* (The Important Thing is to Love), Paris, 1974

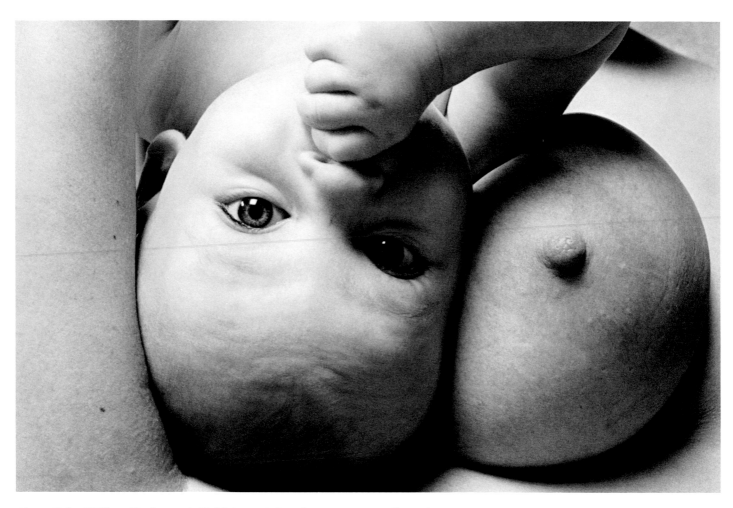

Above: John Willis, *Mother and Child #2*, 1986; *Below*: Peggy Jarrell Kaplan, *Untitled*, 1979

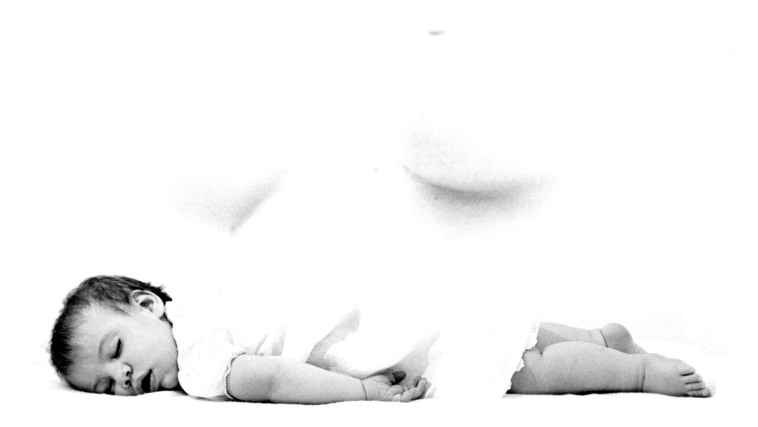

BREASTS

BY CHARLES SIMIC

I love breasts, hard
Full breasts, guarded
By a button.

They come in the night.
The bestiaries of the ancients
Which include the unicorn
Have kept them out.

Pearly, like the east
An hour before sunrise,
Two ovens of the only
Philosopher's stone
Worth bothering about.

They bring on their nipples
Beads of inaudible sighs,
Vowels of delicious clarity
For the little red schoolhouse of
 our mouths.

Elsewhere, solitude
Makes another gloomy entry
In its ledger, misery
Borrows another cup of rice.

They draw nearer: Animal
Presence. In the barn
The milk shivers in the pail.

I like to come up to them
From underneath, like a kid
Who climbs on a chair
To reach a jar of forbidden jam.

Gently with my lips,
Loosen the button.
Have them slip into my hands
Like two freshly poured beer-
 mugs.

I spit on fools who fail to include
Breasts in their metaphysics,
Star-gazers who have not
 enumerated them
Among the moons of the earth...

They give each finger
Its true shape, its joy:
Virgin soap, foam
On which our hands are cleansed.

And how the tongue honors
These two sour buns,
For the tongue is a feather
Dipped in egg-yolk.

I insist that a girl
Stripped to the waist
Is the first and last miracle,

That the old janitor on his
 deathbed
Who demands to see the breasts
 of his wife
For one last time
Is the greatest poet who
 ever lived.

O my sweet, yes, my sweet no,
Look, everyone is asleep
 on the earth.

Now, in the absolute immobility
Of time, drawing the waist
Of the one I love to mine,

I will tip each breast
Like a dark heavy grape
Into the hive
Of my drowsy mouth.

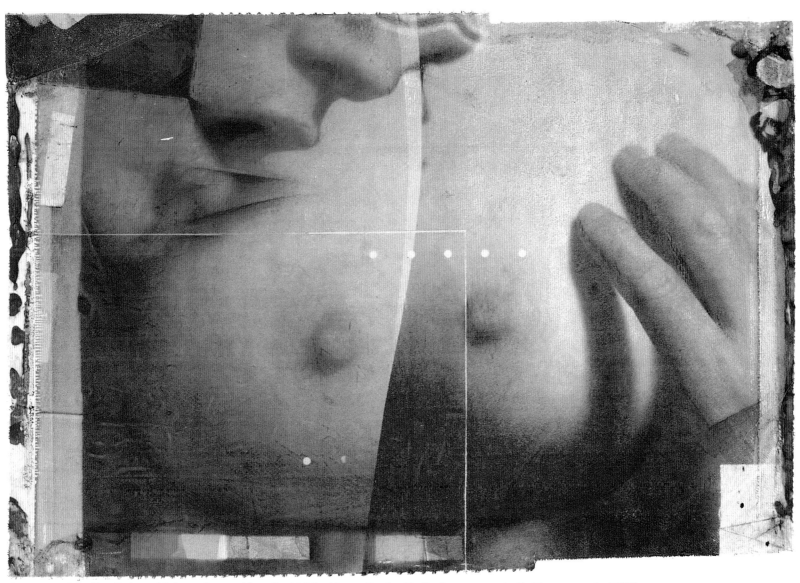

Opposite: Carollee Pelos, Afghan shrine (detail), 1983; *Above*: Paolo Gioli, *Autoanatomie* (Self-anatomy), 1987

The Story of the Tiger

by Dario Fo

Translated by Ron Jenkins

When we came down from Manchuria with the Fourth and the Eighth Armies, and almost all of the Seventh, we were marching day and night; thousands and thousands of us, loaded with packs, dirty, exhausted; and we kept going, with horses that couldn't keep up and died; and we ate the horses, we ate the donkeys that dropped dead, we ate the dogs, and when there wasn't anything else to eat we ate the cats, the lizards, the rats. Imagine the dysentery that came of it all. We shit ourselves in such abundance that I think for centuries to come that path will have the tallest, greenest grass in the world.

We were dying; the soldiers of Chiang Kai-shek were shooting at us...those white bandits were shooting at us, shooting at us from all sides every day...we were trapped... they waited for us behind the walls of the villages, they poisoned the water, and we were dying, dying, dying.

We got to Shanghai and kept going till we could see the Himalayas spread out high before us. And there our leaders said, "Stop. There could be a trap here, an ambush. Some of Chiang Kai-shek's white bandits could be up on the mountain tops waiting for us to come along the gorge. So, all of you in the rear guard, go up there and cover us as we pass through."

So we climbed up, all the way to the top of the ridge to make sure that nobody up there would shoot us in the

ass. And our comrades passed through, marching, marching, marching, and we cheered them on.

"Don't worry, we're here, we'll watch out for you.... Go on...go on...go on."

The passage took almost a day, until finally it was our turn. We came down.

"And now who's going to guard our asses?"

We came down scared, looking down into the bottom of the valley; all of a sudden, just when we got to the gorge, these bandits jumped down from above and started shooting at us: BIM BIM BAM.... I saw two big rocks and threw myself in between them. Under cover I started shooting: BAM! I looked out. My leg, the left one, was out in the open.

"Damn, let's hope they don't see me."

BAM!

They saw me. Hit me right in the leg. The bullet went in one side and came out the other. It grazed one testicle, almost hit the second, and if I'd had a third, it would have been smashed to bits.

The pain.

"Damn," I said, *"They hit the bone."* No, the bone was saved.

"They got the artery...no, the blood's not gushing."

I squeezed it, squeezed it to force the blood out. I tried to walk softly, softly. I managed to walk with a little limp. But after two days the fever started, fever that made my heart feel like it was pounding down into my big toe. TUM, TUM, TUM. My knee swelled up and I had a big bulge in my groin.

"It's gangrene. Damn it. Gangrene."

The putrid blood began to give off a bad odor all around me, and my comrades said, ***"Can you stand back a little. That stink's too much."***

They cut two sticks of bamboo, eight or ten meters long. Two of my comrades lined up, one in front of me, the other behind, with the sticks on their shoulders. I walked between them supported under my armpits, barely putting any weight on my legs.

They walked with their faces in air and their noses stopped up so they wouldn't have to breathe in the stench.

One night we came up close to what was called the great "green sea," and all night long I'd been shouting, cursing, and calling for my mother. In the morning a soldier, a comrade who was like a brother to me, pulled out an enormous pistol and pointed it here. (Points to forehead.)

"The pain's too much for you. I can't stand to see you suffer like this. Listen to me...just one bullet and it's over."

"Thanks for your solidarity and understanding, I appreciate your good intentions, but maybe some other time, don't trouble yourself, I'll kill myself on my own when the time comes. I've got to resist. I've got to live. Go ahead without me. You can't keep on carrying me like this. Go away. Go away. Leave me a blanket, a pistol to hold, and a little container of rice."

So they left. They left. And as they trudged off along that "green sea" I started to shout.

"Hey comrades, comrades.... Dammit.... Don't tell my mother that I rotted to death. Tell her that it was a bullet, and that when it hit me I was laughing. Hey..."

But they didn't turn around. They pretended not to hear so they wouldn't have to turn around and look at me, and I knew why: their faces were all streaming with tears.

Me, I let myself fall to the ground, wrapped myself in the blanket and started to sleep.

I don't know how, but I dreamed a nightmare, and I thought I saw the sky full of clouds that broke open and showered down a sea of water. WHOOOSH. A great big thundercrash. I woke up. There really was a sea. A storm. All the water from the rivers was flooding the valley. Torrents of water swirled around me. PLEM, PLUC, PLOC, PLAM. It was rising up to my knees.

"Damn, instead of rotting to death, I'm going to end up drowned."

I climbed up, up, up onto a steep gravelly slope. I had to hold on to the branches with my teeth. My nails broke. Once I got up on the ridge, I started running across the plateau, dragging my dead leg behind me, till I jumped into a swirling torrent of water and swam, swam with all the strength left in my arms to the other side and lifted myself up onto the bank, and all of a sudden in front of me there was...oooh...a big cave, a cavern. I threw myself into it.

"Saved. Now I won't drown. I'll rot to death."

I look around. It's dark. My eyes adjust.... I see bones, the carcass of a devoured beast, an enormous carcass... a colossus.

"But what could eat a thing like that? What kind of beast is it? Let's hope it's moved out, with the whole family, that it's drowned in the flooded rivers."

So I go to the back of the cave.... I lie down. I start to

hear the pounding again. TUM, TUM, my heart beating down to my big toe.

"I'm dying, dying, dying. I'm going to die."

Suddenly, in the bright light at the entrance to the cave, I see a shadow, like a silhouette. An enormous head. But what a head. Two yellow eyes with two black stripes for pupils...big as lanterns. What a tiger. What a beast. A tigress-elephant. OOEH. In her mouth she has a tiger cub, its belly swollen with water. A drowned cub. It looks like a sausage, a pumped-up bladder. She tosses it onto the ground... TOOM...she presses...with her paw on its belly...water comes out...BLOCH...from its mouth; it's drowned to death. There was another tiger cub running between its mother's legs that looked like it had a melon in its stomach; it too was dragging around a belly full of water. The tigress lifts her head, sniffing...SNIFF, SNIFF...the air of the cavern.

"Damn, if she likes rancid meat, I'm screwed."

She turns toward me...she's coming forward, she's coming. This head getting bigger, getting bigger, overflowing. I feel my hair standing on end so stiff that it makes noises...GNIAACH...the hair on my ears stood up too, my nose hairs...and the rest of my hairs: a brush.

"She's coming, she's coming, she's right next to me, she sniffs me."

"AAAHHAARRRR"

And she went away, slinking to the back of the cave where she was stretched out and pulled her son, the cub, against her belly. I watched: her nipples were full of milk almost to bursting, it had been days since she'd nursed, with all the water flooding. And on top of it all, her son, the other cub was drowned to death.... The mother pushed the little one's head close to her nipple and said:

"AAHHAARRRR"

And the tiger cub:

"IAAAHHAA"

"OAAHHHAARRR"

"AAAAH"

"OAAAHAAARRRRR"

"IIAAAHHH"

A family quarrel. He was right, the poor little tiger baby; he was full up to his ears with water, like a little barrel... what could he do? The cub ran to the back of the cave and had a tantrum.

"AAHHHHAAEEAA"

The tigress is furious. She turns to look at me, gets up and stares at me. Me! Damn, she's mad at her son and

now she's going to take it out on me. What do I have to do with it? Oh, no, I'm not even a relative. IGNA TUM, TUM, TUM (Makes the sound of hair standing on end.) The brush. She's coming close, lantern eyes, she turns sideways, PAC, a tit in my face.

"But what kind of way is this to kill people, tit bashing?"
She turns her head and says:
"AAAHARR," as if to say, **"Suck it."**
I hold her nipple with two fingers, and put it against my lips.
"Thank you, anything to make you happy." (Mimes taking tiny sip from the nipple.)
I should never have done it. She turned, looking nasty:
"AAAHHHAARRR"
Never spurn the hospitality of lady tigers. They become beasts. I took her teat and...CIUM, CIUM, CIUM.... (Pantomime of gluttonous rapid sucking.) Delicious. Tiger milk...delicious. A little bitter, but, oh my dear so...creamy: it went down sliding and rolling around my empty stomach...PLOC, PLIC, PLOC, then it found my first intestine...TROC, it sloshed all around the empty intestine.... I hadn't eaten for fifteen days. PRFII, PRIII, PFRIII, the milk was rampantly flooding all the rest of my intestines. Finished. PCIUM, PCIUM, PCIUM. (Mimes folding up the empty teat like it was a little sack.)
"Thank you."
She takes a step forward, TAH: another tit. It's amazing how many tits tigers have! A titteria. I started sucking another one, I wanted to spit out a little, but she was always there like this, keeping an eye on me.
If I spit out even a drop of milk she's going to eat me alive. I didn't even stop to breathe: PCIUM, PCIUM, PCIUM! I sucked, I sucked. The milk was going down, I was starting to choke: PLUC, PLUM, PLOC, I could hear the milk seeping all the way down to the veins in my legs. It had such a strong effect that I could almost feel my heart beginning to pound less strongly. I could even feel the milk going into my lungs. I had milk everywhere.
Finished, PLOC. She turned. Another titteria. I felt like I was in a factory, on the assembly line. My stomach was expanding fuller, fuller, I got to the point, squatting like I was, with my swollen belly, that I looked like a Buddha. PITOM, PITOM, PITOM, repeat-action burps. And I had my butt muscles squeezed tight enough to make my ass choke.
"If I get dysentery from the milk, and start shitting myself,

she's gonna get mad, pick me up, dip me in the milk like a donut in a cup of coffee and eat me."
So I sucked, and I sucked, and suck-suck by the end, my friend, I was flooded, engulfed, drunk with milk. I didn't know where I was. I could feel milk coming out of my ears, out of my nose, I was gurgling: PRUFF, I couldn't breathe...PRUFFFF.
The tigress, having terminated her service, licked my face from bottom to top: BVUAAC. My eyes got pushed up like a mandarin's. Then she goes off to the back of the cave, with her cat walk, throws herself to the ground and sleeps. I, stuffed to the gills, sat still. (Mimes the statuary position of the Buddha.)
"If I move so much as even an eye, I'll explode...PFRU-UUH."
I don't know how, but I fell asleep, calm and peaceful as a baby. I woke up in the morning, partially emptied. I don't know what happened, but the ground around me was all wet with milk. The tigress, I look, (Looks for the tigress.) she's not there, neither is the cub, gone...they went out, gone for a morning piss. I wait a while.... I was nervous. Every time I heard a noise I was afraid some wild animal was coming to visit. Some other ferocious beast coming into the cave. I couldn't say:
"Sorry, the lady of the house isn't in, she's gone out, come back later, would you like to leave a message?"
I waited, worried. Finally, in the evening, she came back. The tigress returned. So silky and beautiful, her nipples were already a little swollen, not like the day before when they were bursting, but half-way, nicely full, and behind her came the cub. As soon as the tigress entered the cave, she sniffed, looked around, glanced my way and said,
"AAAHHAARRR" as if to say, **"Are you still here?"**
And the cub chimed in:
"OOOAAAHHHAA"
And they went to the back of the cave. The tigress stretched out on the ground. The cub's stomach was a little less swollen with water than before, but every so often, BRUUAAC! he spit up a drop, then he curled up next to his mom. Mom gently took hold of his head, and put it next to her nipple.
"IAAHAA" (Mimes the cub's refusal.)
The tigress:
"OAAHAA"
"IAAHAA"

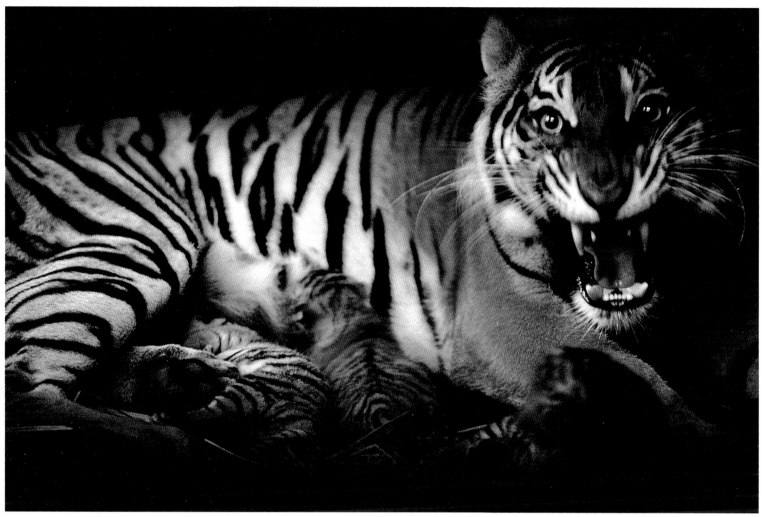
Michael Nichols, Tiger farm, Thailand, 1997

And the cub ran away. He wanted nothing to do with anything wet. (Mimes the gesture of the tiger turning to the soldier, and the soldier obediently coming over to drink the milk.)

"PCIUM, PCIUM, PCIUM." What a life. While I was sucking, she started to lick my wound:

"Oh dammit, she's tasting me. Now if she likes it, while I'm sucking, she'll eat me."

But no. She was just licking, just licking. She wanted to heal me.

She starts sucking out the rot inside the swelling. PFLUUU WUUAAMM she was spitting it out PFLUUUU she was draining it all out: WUUAAC! Goddammit to hell, she was good. She spread her saliva, that thick saliva that tigers have, all over the wound. And suddenly it occurred to me that tiger balm is a marvelous miraculous medication, a medicine. I remember when I was a child, old people came to my village who were healers, witches,

and they came with tiny jars full of tiger balm. And they went around saying:

"Come here, ladies. You have no milk? Smear your breasts with this balm. And TOCH: You'll get two breasts big and bursting. You old ones, are your teeth falling out? A little bit on your gums...THOOMM locks those teeth in tight as fangs. Do you have warts, boils, scabs...infections? One drop and they're gone. It cures everything."

And it's true, it was miraculous that balm. And it was real tiger balm, no tricks. They collected it themselves. Think of the courage they had, those old witch doctors, going on their own to get saliva from inside the mouth of a tiger, while she was sleeping, with her mouth open. PFIUUTT...PFIUUTT (Rapid gesture of saliva gathering.) and running away. You can recognize most of them because they have short arms. (Mimes someone with lop-sided arms.) Professional hazard.

Anyway, it might have been my imagination, but it seemed that as she was licking and sucking, I felt my blood thinning out again and my big toe getting back to normal and my knee beginning to move...my knee was moving! Damn, this was the life. I was so happy that I started singing while I was still sucking, whistling. I got confused and instead of sucking out, I blew in. PFUM... PFUM...like a balloon. (Makes gesture of quickly deflating it before the tigress notices.) All out! The tigress, content, like this (Makes expression of tiger's satisfaction.) she gives me the usual lick and goes to the back of the cave. I should mention that while the mother was licking me, the cub was there watching, all curious. And when the mother was finished, he came near me with his little tongue out, as if to say:

"Can I lick too?"

Tiger cubs are like babies, everything they see their mother do, they want to do too.

"You want a lick? Careful with those little baby teeth of yours (Threatens cub with his fist.) *Careful not to bite, eh."*

So he comes close...TIN...TIN...TIN...his little tongue licked my face till it tickled.... Then after a while: GNAACCHETA a bite. I had his testicles within range, PHOOMMM (Makes the gesture of throwing a punch.) Ball's eye! GNAAAA! Like cat lightning! He started running up the walls of the cave like he was motorized.

You have to earn a tiger's respect immediately, when they're still young. And in fact, from that time on, when he passed near me, the dear thing, he didn't go in by profile, he paid attention. He walked like this. (With rigid arms and legs, alternately crossing over one another, he indicates how the cub walks by him, worrying about keeping his distance and protecting his testicles.)

Well, the tigress was sleeping and the cub fell asleep, and I slept too. That night I slept deeply and peacefully. I didn't have any more pain. I dreamt that I was home with my wife, dancing, with my mamma, singing. When I woke up in the morning neither the tigress nor her cub were there. They had gone out. *"What kind of family is this here? They don't spend any time at home. And now who's going to take care of me? They could be out running around for a week."*

I waited. Night came. Now they're out at night, too.

"What kind of mother is that? A baby, so young, to bring him out gallavanting around at night. What will he become when he grows up? A savage."

The next day at dawn they came back. At dawn! Just like that, as if nothing had happened. The tigress had a huge animal in her mouth, the way it was killed, you couldn't tell what it was. A gigantic goat that looked like a cow.... With enormous horns. The tigress came into the cave: SLAAM, she threw it on the ground. The cub pranced in front of me, saying:

"AAHHAARR" as if to say, "I killed it myself." (Shows his fist and mimed the terrorized reaction of the cub walking cross-legged.)

Okay, let's get back to the big goat. The tigress opens her big claws, tosses the goat down on its back with its belly up. VRROMM a deep gash...UUAACH...she rips open the stomach, the belly. Pulls out the guts, all the intestines, the heart, the spleen.... BORON, BORON.... She scrapes it out, all clean.... The cub...PLON, PLOIN...jumps inside. The tigress...what a rage! **"OOAAHHAAAA"**

You can get into trouble stepping on a tiger's lunch. They get mad. Then the tigress puts her whole head in the belly, inside that cavernous stomach... with the cub still in there...OAHAGN...GNIOOMM...UII NOOM... UANAAMM...GNOOM.... What a racket...it'd break your ears off.

They ate the whole thing in an hour. Every bone sucked clean. The only thing left was a piece of the rear end with the tail, the thigh, the knee of the beast, and a hoof at the end. The tigress turned to me and said:

"OAAHAAA" as if to say: **"Are you hungry?"**

She grabbed the leg and threw it over to me.

"PROOOMM..." as if to say, **"Have a little snack."** (Gesture of impotence.)

"FHUF.... Me, eat that? That stuff's as tough as nails. I don't have teeth like yours.... Look how hard that is, like leather! And then there's the fat and the fur...all those bits of gristle.... If there was a little fire to roast it over for a couple of hours! A fire, damn! Sure, there's wood. The flood washed out all those roots and stumps." I go out, I was already walking, with just a little limp; I went out in front of the cave where there were some tree trunks and stumps; I started to drag in some big pieces, and then some branches, then I made a pile like this, then I took some dry grass, some leaves that were around, then I crossed the two horns, two bones, and over them I put the goat leg, like it was on a spit; then I looked for some round stones, the white sulfur ones that make sparks when you rub them together. I found two nice ones, started scratching away, and...PSUT...PSUT...TAC

(He mimes the beating of the rocks.) like shooting stars... tigers are afraid of fire. The tigress is back in the cave.

"OOOAAHAAAA" (He makes menacing gestures as if to the tiger.)

"Hey, what's the matter? You ate your disgusting ugly meat? Raw and bloody? I like mine cooked, okay? If you don't like it, get lost." (Mimes the tigress cowering in fear.)

You have to show a female who's boss from the start. Even if she's wild. I sat down with my rocks. FIT...PFITT... PFIITT...fire. Slowly catching, rising...the flames leaped: QUAACC... All the fat started to roast and the melted fat dripped down on the fire.... It let off a thick black smoke... it drifted towards the back of the cavern. The tigress, as soon as the cloud of smoke reached her, said:

"AAHHHIIAAAA" (A roar that sounds like a sneeze.)

"Smoke bother you? Out! And you too, tiger baby." (Threatens cub with fist and mimes the frightened response of the cross-legged walk.) *"Out."*

And I am roasting, roasting, roasting, basting, basting, and turning. FLOM...PSOM...PSE.... But it still gives off a disturbingly savage aroma. (Goes out.)

"If only I had some seasoning for this meat." That's it, outside I've seen wild garlic.

I go out, in the clearing in front of the cave, right there... I pull out a nice bunch of wild garlic. THUM.... Then I see a green shoot, I pull:

"Wild onion."

I also find some hot peppers.... I take a sharp piece of bone, make some cuts in the thigh and stuff in the garlic cloves with the onion and peppers. Then I look for some salt, because sometimes there's rock salt inside caves. I find some saltpeter.

"That'll do, even though saltpeter's a little bitter. There's also the problem that the fire might make it explode. But that's not important, I'll just be careful."

I stuff some pieces of saltpeter into the cuts. And after a while, in fact, it flames up.... PFUM...PFAAMM... PFIMMM.... The tigress:

"OAAHHAA..." (Mimes the tigress getting scared.)

"This is a man's work. Out. Get out of my kitchen."

Turn, turn, turn...now it's giving off a clear smoke, and what an aroma. After an hour, my friend, the aroma was heavenly.

"HAHA, so delicious."

SCIAAM: I peel off a piece of meat. (Mimes tasting it.) PCIUM, PCIUM.

"Ah, so delicious."

It's been years and years since I ate anything like this. What sweet, heavenly flavor. I look around. It's the cub... he had come in and was standing there licking his whiskers.

"You want a taste too? But this stuff's disgusting to you. You really want some. Look. (Indicates rapidly slicing some meat and throwing it to the cub who wolfs it down in a second.) *OHP"*

He tasted it, swallowed and said:

"OAHA."

"Good? You like it?... Shameless brute. Take that. OPLA." (Again mimes cutting and throwing the meat to the cub.)

"EHAAA... GLOP...CL... OEEE... GLOO... OEH-AAH-HAA."

"Thank you, thank you.... Yes, I made it myself. You want some more? Watch out your mother doesn't find out that you eat this stuff."

I cut off a nice piece of filet.

"I'll keep this for myself. The rest is too much for me, so I'll leave it for you: take the whole leg." (Mimes the action of throwing the goat leg to the cub.)

BLUUMM...it hit him in the face and flattened him. He picked it up and staggered around with it like a drunk. Then mom shows up. What a scene!

"AAAHHAAA what are you eating...this disgusting burnt meat? Come here. Give it to me. AAH-HAAAAA"

"OOOHHOOOOCH"

A piece of meat gets stuck in Mom's mouth. She swallows it. She likes it.

"UAAHAAAA" says the mother.

"UUAHAAA" answers the cub. (Mimes the mother and son fighting over the meat.)

"An argument."

"PROEMM...SCIOOMMMM...UAAAMMM..."

The bone. Licked clean. Then the tigress turns to me and says:

"OAAHAAAA, isn't there any more?"

"Hey, this one's mine." (Pointing to the piece he had cut a moment ago.)

While I was eating, the tiger came over to me. I thought she wanted to eat my meat, but she just wanted to lick me. What a wonderful person. She licked me and then went over to her usual spot. She stretched out on the ground. The baby was already asleep, and pretty soon I fell asleep myself.

When I woke up in the morning, the tigers were already gone. It was getting to be a habit with them. I waited all day and they didn't come home. They didn't even show up that evening. I was a nervous wreck. The next day they still hadn't come back.

"Who's going to lick me? Who's going to take care of me? You can't go leaving people home alone like this."

They came back three days later.

"Now it was my turn to make a scene."

Instead I stood there dumbstruck, speechless: the tigress walked in with an entire beast in her mouth. Double the size of the last one. A wild bison. I don't know what. The cub was helping her carry it. They both stepped forward...BLUUMM sideways...like they were drunk with fatigue...PROOM...they came up to me. PHOOAAH-HAMMM....(Mimes the tigers unloading the dead animal.) The tigress says:

"HAHA...HAHA..." (Imitating the panting of the tiger.) And then:

"AAHHAAAAAA" As if to say: **"Cook it."**

(Putting his hands in desperation to his face.) Don't let tigers get away with bad habits.

"Excuse me, tiger, you must be mistaken. You don't expect me to sweat and slave over a hot stove while you're out having fun. What do I look like? Your housewife, me!" (Mimes the tiger preparing to attack him.)

"OOAAHHAAAOOAAHHAAAAOO"

"Stop. OHO, OHO...OHO! So that's how you get your way. Can't we talk things over anymore? How 'bout a little dialectics over here. Okay, okay...OHEOH.... Don't get all hot and bothered about it. All right, I'll be the chef.... I'll cook. But you two, go get the wood."

"OOAHHAAH?" (Indicated the tiger pretending not to understand.)

"Don't play games. You know what wood is. Look here, come outside, that's wood, those are stumps, bring all these pieces in right away."

She understood all right: she gathered up the wood right away, all the stumps, back and forth, so that in an hour the cave was half-full.

"And you, tiger baby, nice life, eh? Hands in your pockets?" (Turns to audience.) He did have his hands in his pockets. He had his claws tucked in and was resting his paws on two black stripes just as if his hands were in pockets.

"Come on. Get to work. I'll tell you what you have to do: onions, wild garlic, wild peppers, everything wild."

"AAHAA"

"You don't understand? Okay, I'll show you. Look over there. That's an onion, that's a pepper."

The poor thing kept going back and forth with his mouth full of garlic, peppers and onions...ha...and after two or three days his breath was so bad you couldn't get near him: What a stink. And I was there all day, by the fire, roasting, falling apart. My knees were scorched, my testicles dried to a crisp. My face was burnt, my eyes were watering, and my hair was singed too, red in the front and white in the back. You couldn't expect me to cook with my ass. It was a dog's life. But they just ate, pissed, and came home to sleep. I ask you: *"What kind of life is that?"*

So one night when I was feeling burnt up all over, I said to myself:

"Enough, I'm cutting the cord."

While the two of them were sleeping, filled to bursting with the food I had intentionally inebriated them with, I crawled towards the exit, and was about to leave, almost outside...the cub reared up screaming:

"AAHHAAAAAA.... Mamma, he's running away."

"Little spy. One of these days I'm going to rip off your balls with my bare hands, cook them up, and give them to your mother to eat stuffed with rosemary."

It was raining. All of a sudden it started to rain: a thunderstorm, I remembered that tigers have a terrible fear of water. So I threw myself out of the cave and started running down the mountainside towards the river... I dived into the river and swam and swam and swam. The tigers came out:

"OOAAHHAA!..."

I answered back:

"OOAAHHAAHHAA!" (Transforms the mime of swimming into a classic obscene gesture.)

I got to the other side of the river, I started running. I walked for days. For weeks, a month, two months, I don't know how far I walked. I couldn't find a hut, I couldn't find a village, I was always in the forest. Finally one morning I found myself on a hilltop looking down on a valley that stretched out below. The land was cultivated. I could see houses down there, a village...a town! With a town square, full of women, babies, and men.

"OHO...people." I ran stumbling down. *"I'm saved, people, I'm a soldier of the Fourth Army, it's me."*

As soon as they saw me coming:

"It's Death. A ghost."

They ran away into their huts, into their houses. And they barred up their doors with sticks and chains.

"But why...a ghost, death...but why? No, people..."

I pass in front of a glass window and see my reflection. I was terrified. My hair was white and wild, my scorched face blackened and red, my eyes looked like burning coals. I did look like Death. I ran to a fountain and threw myself in.... I washed myself, I scrubbed myself with sand all over. Finally I came out clean again.

"People, come out. Touch me.... I'm a real man, flesh and blood, warm...come, come feel me.... I'm not Death."

They came out, still a little scared. A few men, a few women, some children, they touched me...and while they were touching me I told them the whole story: (He recounts his adventures in double time, semi-onomatopoetically).

"I'm in the Fourth Army, I came down from Manchuria. When they shot me in the Himalayas, they hit me in the leg, just missed my first and second testicles, if I'd had a third, it'd been shot to bits...then, three days, gangrene...a big pistol pointed right at me: "Thanks maybe some other time." PROM, I fell asleep, PROM, rain and water, water, PROM, I'm in a cave, a tigress comes, her cub's drowned...she comes up to me, my hair stands on end...a brush! Breast feeding, so I tit, tit, tit, just to make her happy, so I suck, I suck, then there's another one: BAM AHAA. A punch in the balls.... Then the next time: BROOOM a giant beast, and me I'm roasting, roasting, roasting, red in the front, white in the back. SCIUM! Mamma, he's running away. I'll rip your balls off. AHAAHHA and I escaped!"

While I was telling my story, they looked at each other, making faces and saying:

"Poor guy, his mind's gone to mush...must have had an awful scare, he's gone mad, poor thing."

"You don't believe me?"

"But yes, yes, of course! It's normal to be breast fed by a tiger...everybody does it. Around here there are people who grow up their whole lives drinking milk from tigers' tits. You ask them, "Where are you going?" "To suck a tiger tit." And then there's all that cooked meat. Oh, how they love it.... Those tigers just can't get enough of cooked meat. We set up a cafeteria just for the tigers.... They come down every week just to eat with us."

I got the impression they were making fun of me.

At that moment we heard the cry of a tiger. **"AAH-HAAAAAAAAAAAAAAA"**

A roar. At the top of the mountain you could make out the profile of two tigers. The tigress and her cub. The cub had grown to be as big as his mother. Months had passed.... Imagine, they'd managed to track me down after all that time. I must have left quite a trail of stink behind me.

"AAAAAHHHAAAAA"

All the people in the village started to scream in fright: ***"Help. Tigers."***

They ran away to their houses and closed themselves in with chains.

"Stop, don't run away...they're my friends, they're the ones I told you about. The cub and the tigress that nursed me. Come out, don't be afraid."

The two tigers came down. BLEM, BLOOMMM, BLEM, BLOOM, when they got within ten meters of me, the mother tiger started to make a scene! But what a scene.

"AAHHAAAAAAAA a fine way to pay me back, after all that I did for you, I even licked your wounds OOHHAAAAAAHHHAAAA I saved your life! EEOOHHAAA things I wouldn't have done even for my own man...for one of my own family... EEOOHHAAA you walked out on me OOHHAAH- HAAA and then you taught us to eat cooked meat, so that now every time EEOOHHAAHHAA we eat raw meat we throw up...we get dysentery, we're sick for weeks. AAAHHHAAAHHAAA"

And I gave it back to her:

"OOHHAAAAA Why did you do what you did? I saved you too with the nursing so your tits wouldn't burst...AHO- LAHHH! And didn't I cook for you, roasting, roasting, till my balls bust, eh? AAAHHHAAA. Behave yourself, eh... even if you are grown up now..." (Threatens tiger cub with fist.)

Then, you know how it is, in a family, when you love each other...we made up. I scratched her under her chin... The tigress gave me a lick...the cub gave me his paw...I gave him a little punch like this...I pull a little on the mother's tail...I gave her a little slap on the breast, the way she likes it, a kick in the balls for the cub, and he was happy. (Turns to the people closed in their homes.)

"We made up, come out...don't be afraid, don't be afraid." (To the tigers.)

"Keep your teeth in AAAMM, like this. (He covers his own teeth with his lips.) *Don't let them see AMMAAA. And keep your claws tucked under your paws, hide your*

claws under your armpits... walk on your elbows, like this." (Demonstrates.)

The people start to come out...a little woman softly stroked the head of the tigress...

"She's so beautiful...guruguruguru...and the other one, so cute...lelelele...and VLAAAMM!" Lots of licking, petting, scratching, for the tiger cub too. And the children. A group of four children climbed right on the tigress's back. Four of them jumped right on, PLOM...PLOM... PLOM...the tigress marched around with them like a horse. Then she rolled over on her side to stretch out. Four more kids grabbed hold of the tiger cub's tail. (Mimes the cub being dragged backwards and resisting by digging his claws into the earth.)

"AAAHHAAHH"

"And I was right behind him, keeping an eye on things (Shows his fist.)*...because tigers have long memories."*

Then they started to play, rolling on the ground and clowning around. You should have seen it: they played all day with the women, the children, the dogs, the cats...a few of them did disappear every once in a while, but nobody noticed because there were so many of them.

One day while they were romping around, we heard the voice of a farmer, an old man who came shouting down from the mountain.

"Help, help, people, the white bandits have come to my village. They're killing all the horses, they're killing our cows. They're carrying off our pigs...they're carrying off the women too. Come help us...bring your guns." And the people said:

"But we don't have guns."

"But we have tigers," I said.

We took the tigers...

BLIM...BLUMM...BLOM...BLAMM...BLAMM...BLAM..., we climbed up the hill, went down the other side to the village. There were soldiers of Chiang Kai-shek, shooting, killing, looting.

"Tigers."

"AAAHHHAAAAA"

As soon as they heard the roars and saw the two beasts, Chiang Kai-shek's soldiers burst their belts, dropped their pants, shit on their shoes...and ran away.

And from that day on, every time Chiang Kai-shek's soldiers showed up in one of the neighboring villages, they'd come calling for us:

"Tigers."

And we'd be off. Sometimes they'd show up from two places at once, from here, from there, they called us from all over. They'd even come to book us a week in advance. One time twelve villages wanted us the same day...what could we do?

"We have only two tigers...we can't go everywhere... what can we do?"

"Imitations! We make imitation tigers!" I said.

"What do you mean, imitation?"

"Simple, we have the model right here, We get some paper and glue to make the heads out of papier-mâché. We make a mask. We put holes in the eyes, so they look just like the tigress and her cub. Then we put in a moveable jaw. Somebody gets in like this with the head and goes: QUAC... QUAC...QUAC...moving the arms. Then somebody else gets behind the first one, then another one puts his arm behind him to make the tail like this. To top it off, we put a yellow blanket over them. All yellow with black stripes. We make sure it covers the feet, because six feet for one tiger would be overdoing it a little. Then we roar. For that we'll need some roaring lessons. Okay, let's have everybody who's going to be an imitation tiger over here for the lessons and the tigers will be the teachers. Come on, you can do it, let's hear how you roar.

"OOOAAHHAA.... There. Now you try." (He turns to a student.)

"OOAAHHAAA"

"Again."

"EOAHHAA"

"Stronger. Listen to the tiger cub."

"EEOOHHAAHHAA"

"Again."

"EEEOOHHAAAAAAAAAA"

"Again. Stronger."

"EOOHHAAAAAAAAAAAAAAA"

"All together." (He begins to conduct them like the maestro of an orchestra.)

"OOOOOOHHHHAAAAAAA"

All day long the noise was so wild that an old man passing by the village, a stranger, was found behind a wall, stone dead of fright.

But when Chiang Kai-shek's soliders came back again:

"Tigers!!!"

"OOOHHHAAHHAAAA"

They ran away, all the way to the sea. And then, one day, one of the party leaders came around to praise us, and he said:

"Good work. Good work. This tiger invention is extraordinary. Our people have more ingenuity, creativity, and imagination than anyone else in the world. Good work. Good work. But the tigers, they can't stay with you anymore, you have to send them back to the forest where they came from."

"But why? We get along great with the tigers, we're comrades, they're happy, they protect us, there's no need..."

"We can't allow it. Tigers have anarchist tendencies, they can't engage in dialectics, we have no role in the party that can be assigned to tigers, and if they can't be in the party, they can't stay in this base. They have no dialectics. Obey the party. Take the tigers back into the forest."

So we said:

"Okay, okay, we'll put them in the forest."

But instead, we put them in a chicken coop: out with the chickens, in with the tigers. The tigers on the bird perches like this. (Mimes the tigers swinging back and forth on the perches.) When the party beaurocrat came by, we had taught the tigers what to do, and they went:

"HIIIIHHHIIIRIIIHHIII," imitating the cluck of a chicken.

The party beaurocrat took a look and said:

"A tiger cock," and walked away.

And it was a good thing we held on to the tigers, because not long afterwards, the Japanese arrived. They were everywhere, little, mean, bandy-legged guys, their asses hanging down to the ground, with huge sabres, and big long rifles. White flags with red circles in the middle on their rifles, another flag on their helmets, and another one up their asses that had the red circle with the rays of the rising sun.

"Tigers."

"OOOOEEEHHAAHHAAAAAAAA!!!!"

Flags off their rifles, flags off their hats. The only flags left were the ones up their asses. FIUNH...ZIUM...away they went, running like a bunch of chickens.

A new party leader arrived and told us:

"Good work, you did well before to disobey that other party leader who was among things a revisionist and a counter-revolutionary. You did the right thing.... You should always have tigers present when there's an enemy. But from now on there'll be no need. The enemy's gone...take the tigers back into the forest."

"What, again?"

"Obey the party."

"Does this have anything to do with dialectics?"

"Absolutely."

"Okay, enough." We still kept them in the chicken coop. And it was a good thing we did because Chiang Kai-shek's men came back again, armed by Americans, with tanks and artillery. They kept coming, more and more of them.

"Tigers."

"OOOOEEEHHAAHHHAAAAA!!!!!"

They ran away like the wind. We beat them back to the other side of the sea. And now there was no one anymore, no enemy. And then all the party leaders arrived. All the leaders waving flags in their hands and applauding us. Some from the party, some from the army. The upper level intermediary officials. The upper-upper level central intermediaries. They all cheered and shouted:

"Good work. Good work. Good work. You did the right thing to disobey: the tiger must always remain with the people, because it is a part of the people, an invention of the people, the tiger will always be of the people...in a museum...no, in a zoo...there forever."

"What do you mean in a zoo?"

"Obey. There's no need for them anymore. No need for the tiger, we have no more enemies. There's only the people, the party, and the army. The party, the army and the people are the same thing. Naturally there is the leadership, because if there's no leadership, there's no head, and if there's no head then there's no element of expressive dialectics which determines a line of conduct which naturally starts at the top but is subsequently developed at the base where the proposals from the top are collected and debated, not as unequally distributed power, but as a kind of determinate and invariable equation, applied in an active horizontal coordinate, which is also vertical, the actions of which are inserted in the thesis position, which is developed not only at the base, to return to the top, but also from the top to the base in a positive and reciprocal relationship of democracy."

"TIGERRRRRRRRRRS" (Mimes a violent aggression towards the party leaders.)

"EEAAAAAAAHHHHHHHHHHHHHAAAAAAAA AAAAAAAAA"

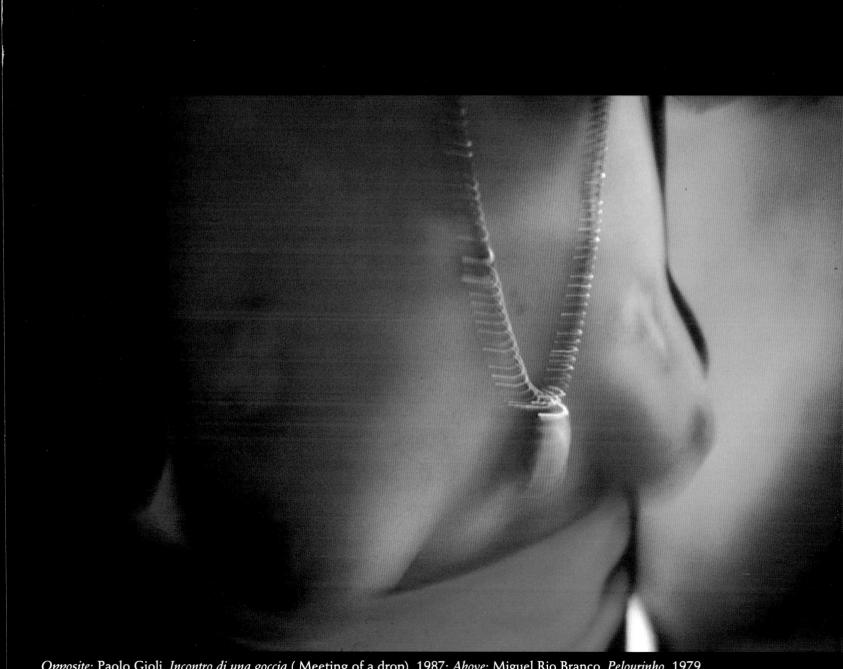

Opposite: Paolo Gioli, *Incontro di una goccia* (Meeting of a drop), 1987; *Above*: Miguel Rio Branco, *Pelourinho*, 1979

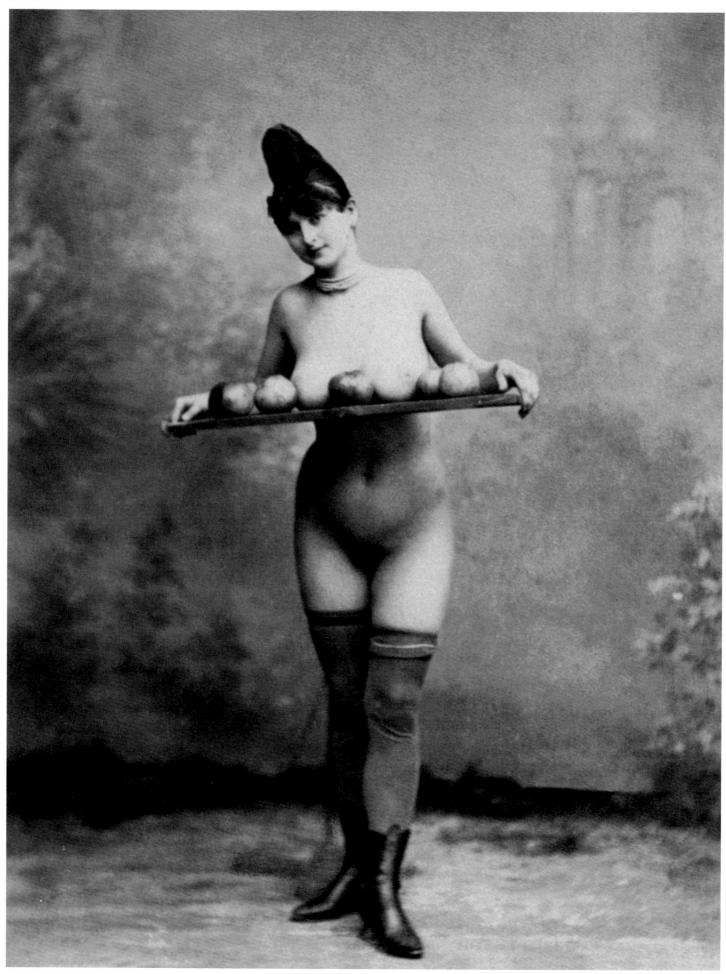

Anonymous, *Achetez des pommes* (Buy some apples), late nineteenth century

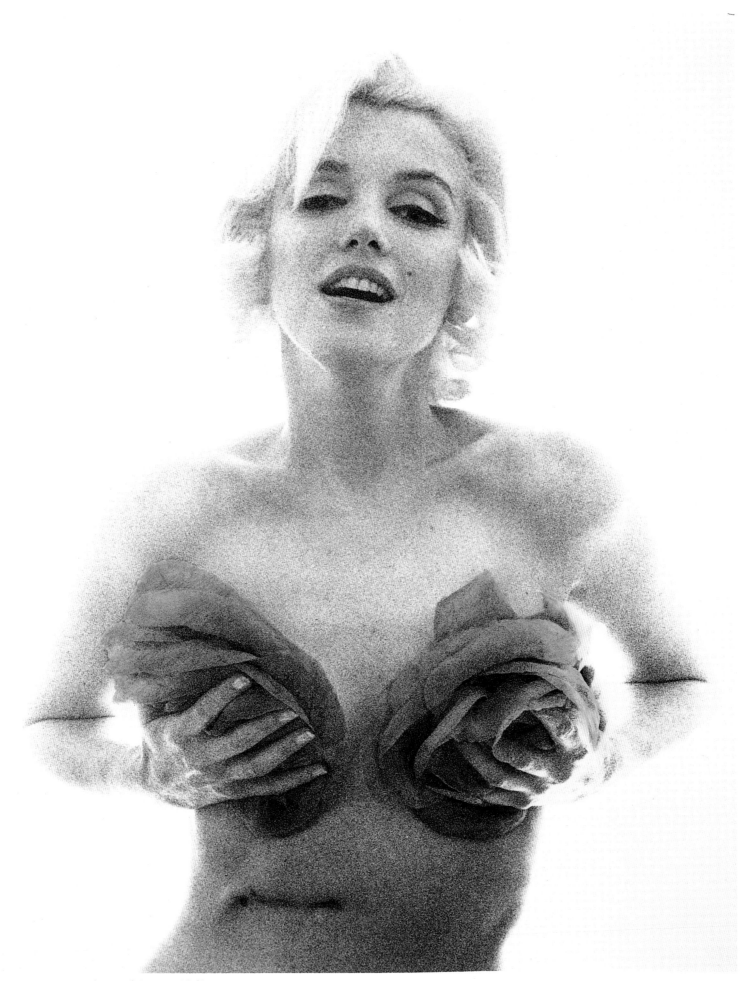

Bert Stern, *Marilyn with Roses*, 1962

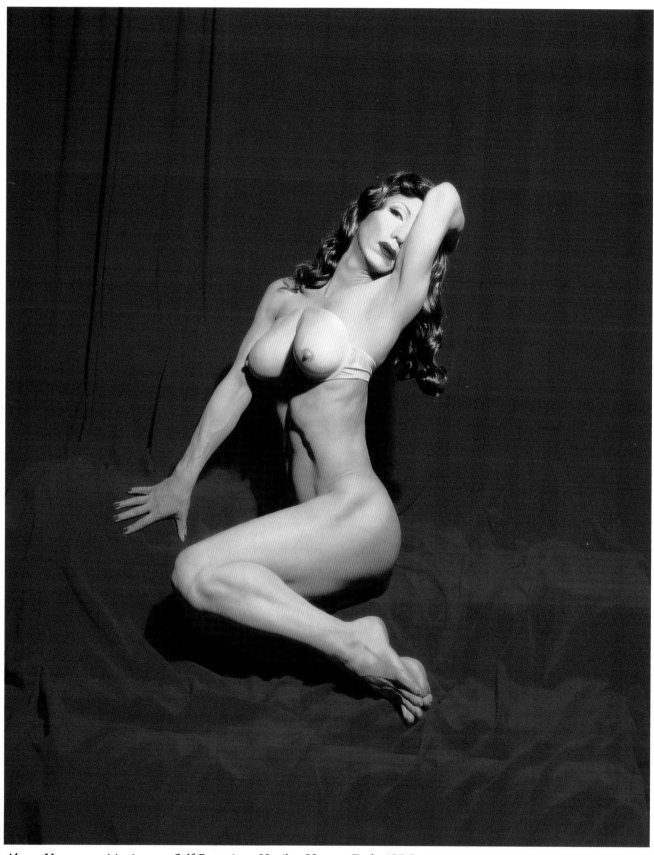

Above: Yasumasa Morimura, *Self-Portrait as Marilyn Monroe (Red)*, 1996
Opposite: Harry Shunk, Yves Klein working with Monique on *Anthropometry #48*, Paris, 1960

Fred W. McDarrah, Charlotte Moorman performing *Opera Sextronique,* composed and accompanied by Nam June Paik, at Filmmakers' Cinematheque, New York City. She was halfway through her performance when she was hauled off by police for exposing her breasts, February 9, 1967.

Above: Fred W. McDarrah, The Ladybirds, 1967; *Pages 88–89*: Annie Sprinkle (with Leslie Barany), *Annie Sprinkle's Bosom Ballet*, 1985
Page 89, lower right: Annie Sprinkle (with Mark Trunz), *Yin-Yang Breasts*, 1985

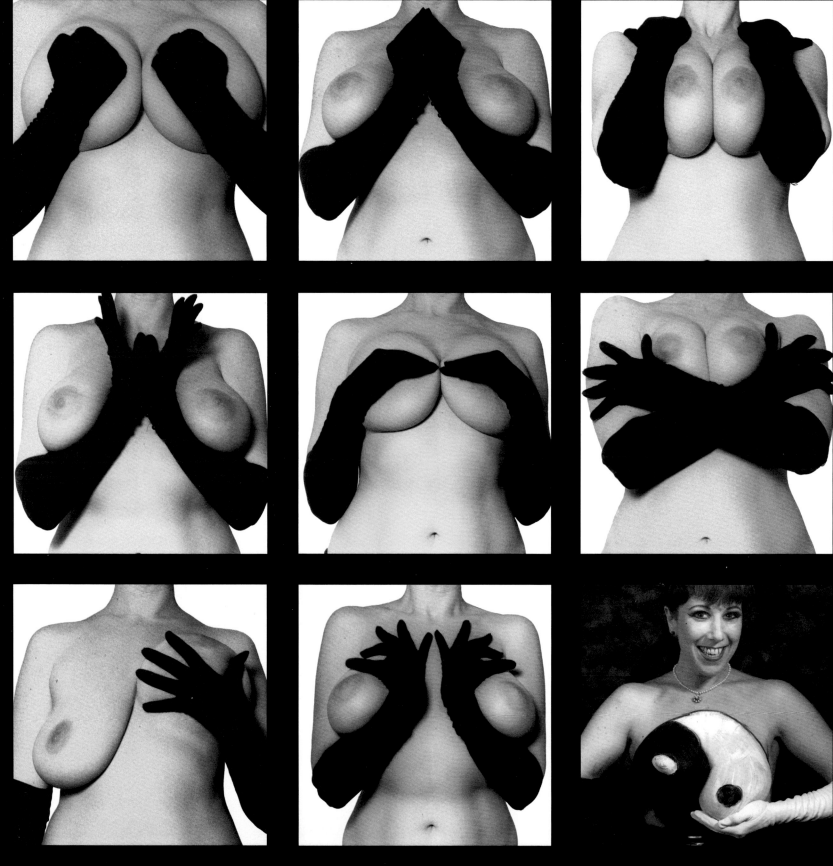

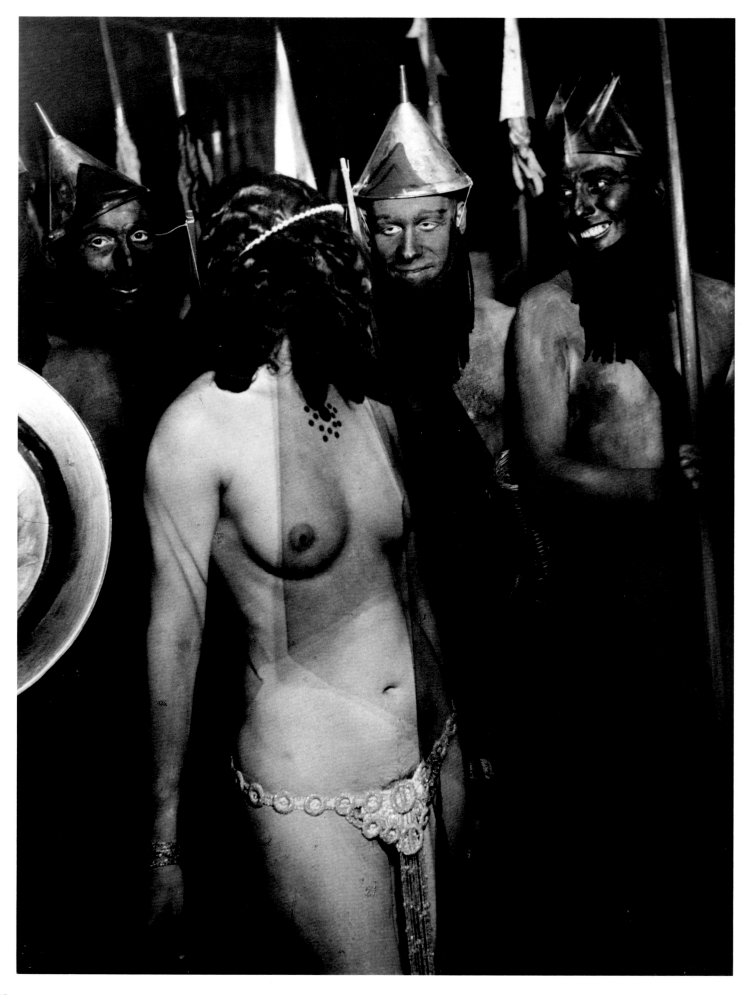

Opposite: Brassaï (Gyula Halász), *Bal de la horde, Montparnasse* (Dance of the crowd, Montparnasse), 1933
Above: Robert Flynt, *Untitled*, 1996

Above: Lisa Crumb, *Lady Liberty*, 1994
Opposite: Dona Ann McAdams, Pat Oleszko performing "Hansel and Grettle: Which, Witch" from *Blue Beard's Hassle: The Writhes of Wives*, performance view at P.S. 122, 1990

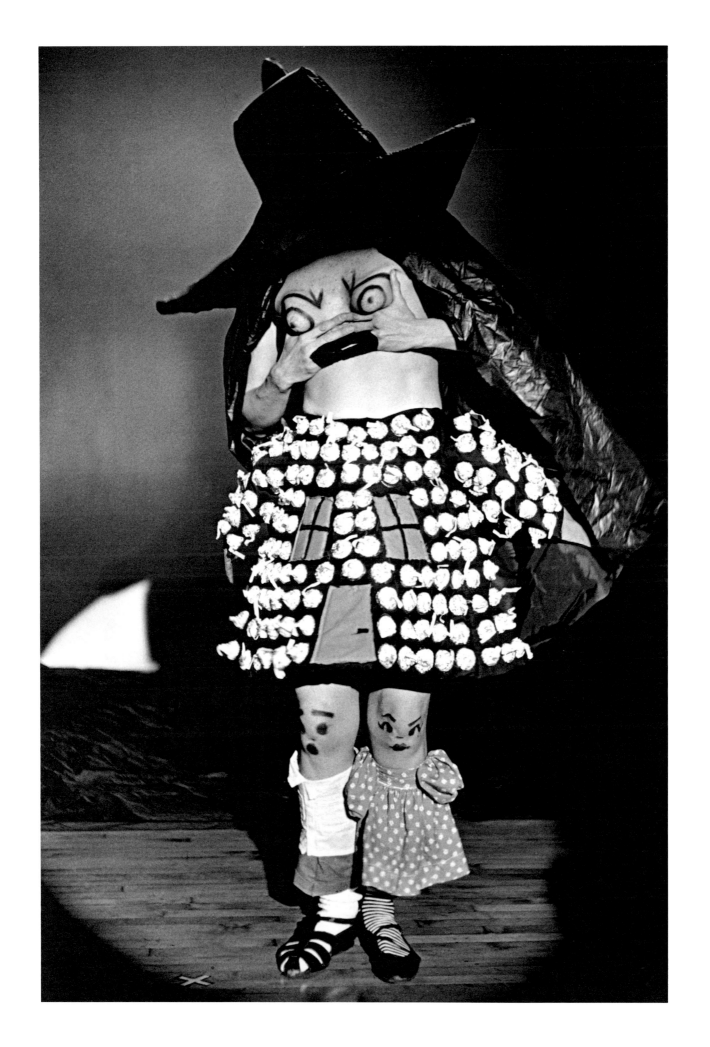

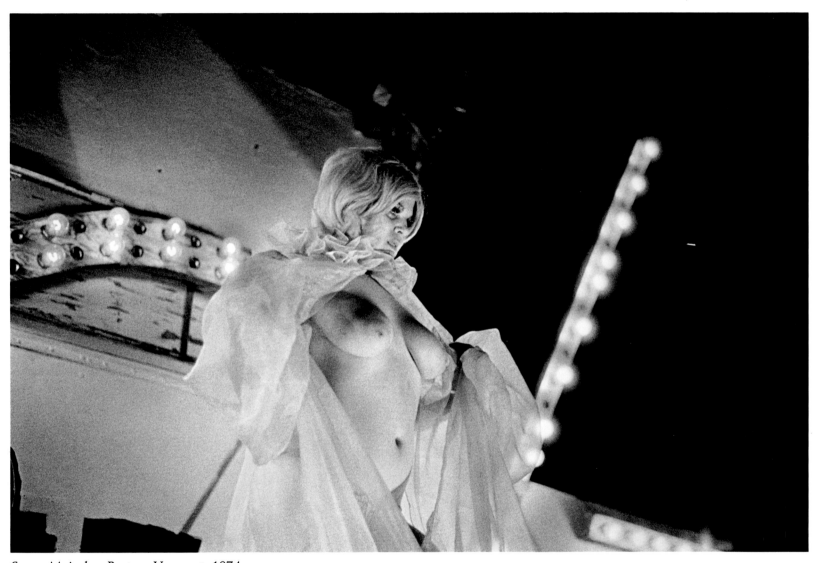

Susan Meiselas, Barton, Vermont, 1974

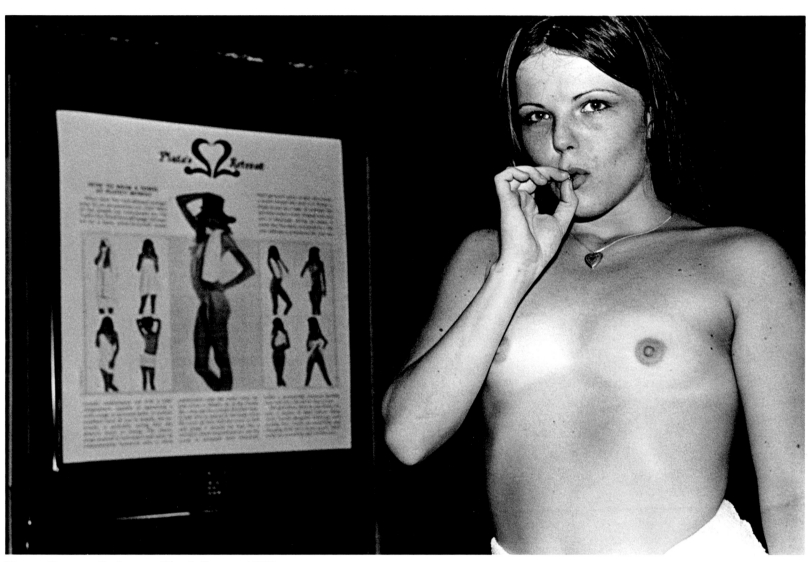

Donna Ferrato, *Swinger at Plato's Retreat*, 1979

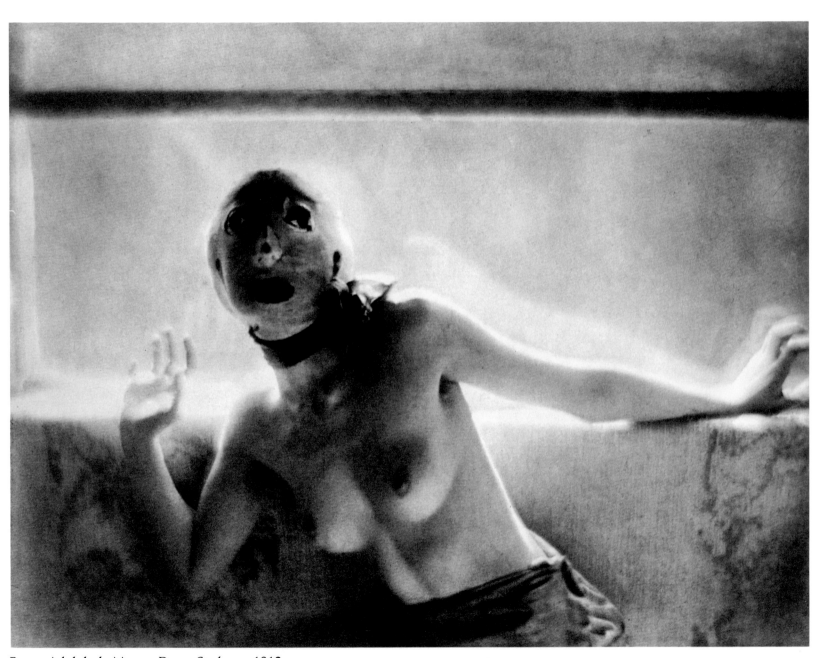

Baron Adolph de Meyer, *Dance Study*, ca. 1912

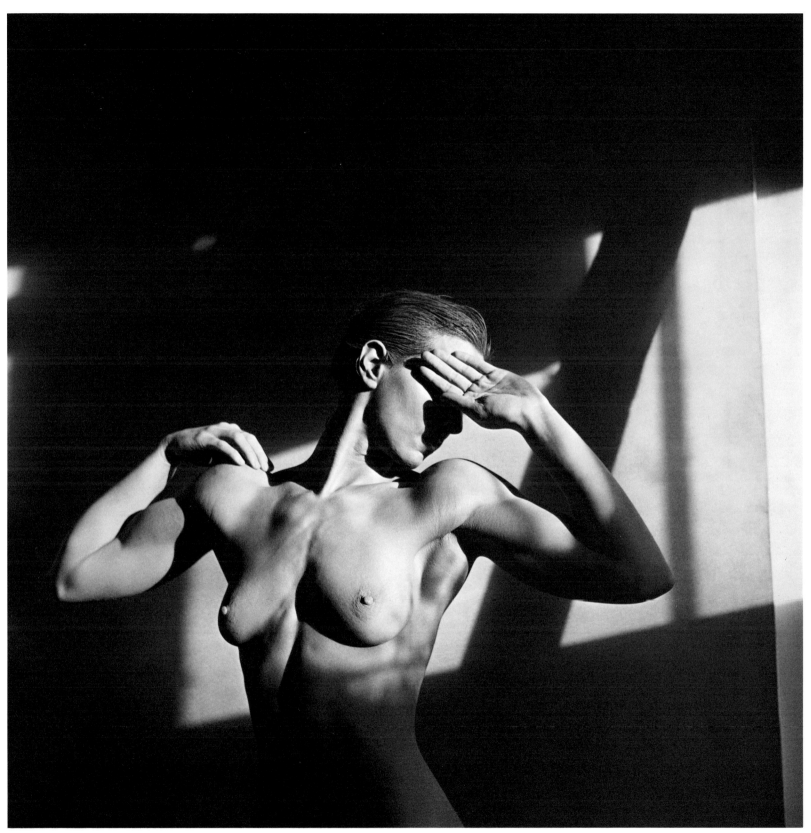

Lynn Davis, *Eve Darcy*, New York City, 1984

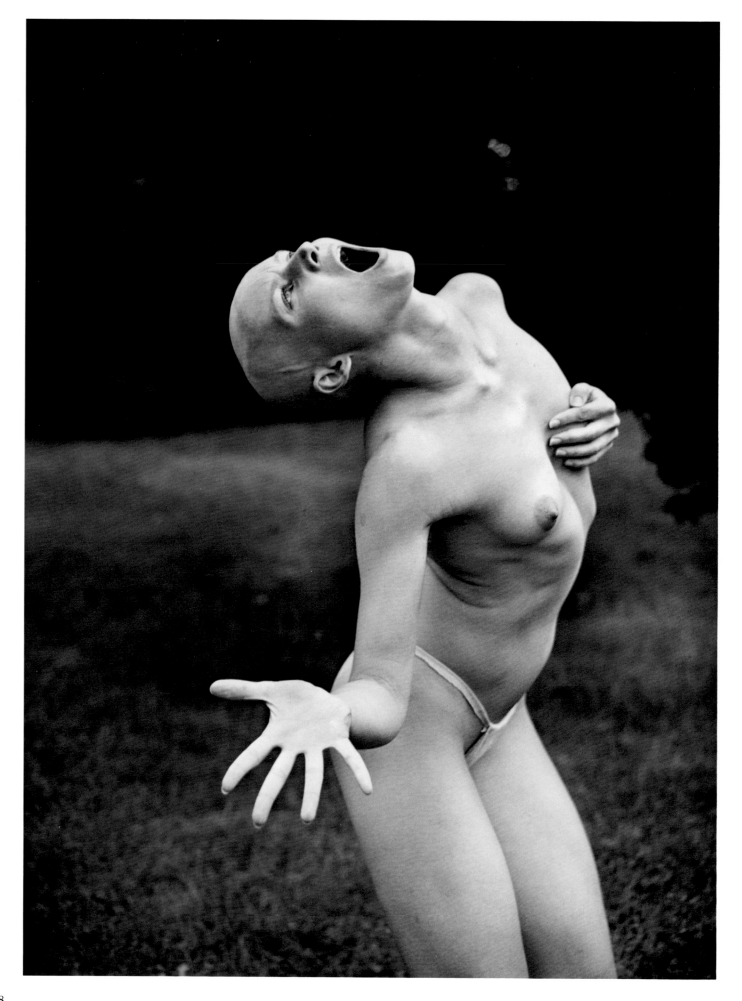

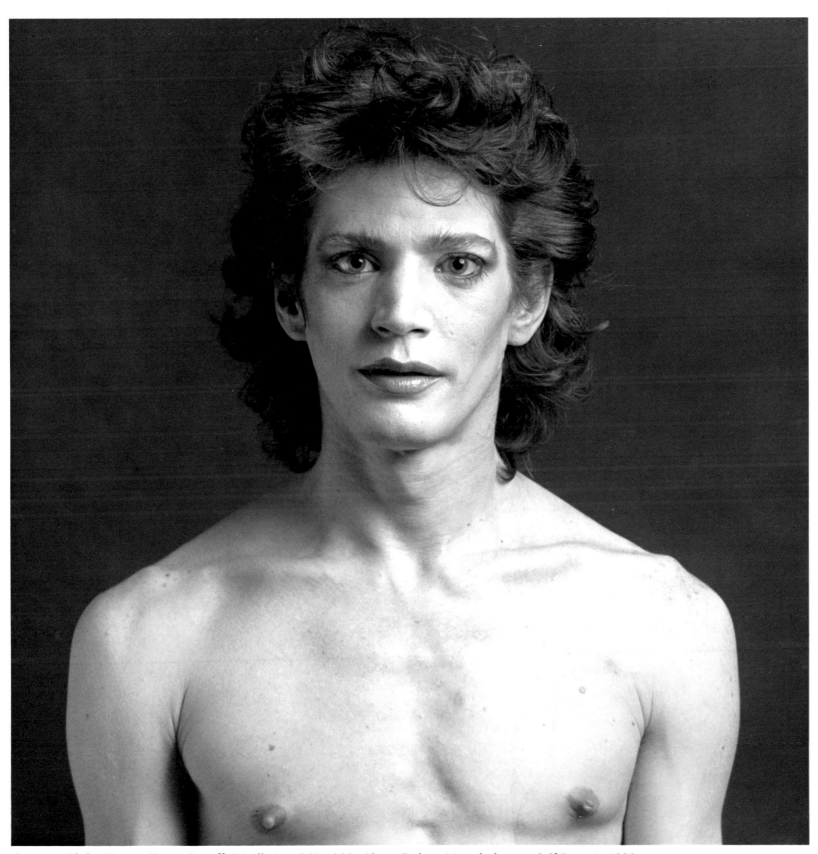

Opposite: Philip Trager, *Tamar Rogoff, Distillations I–V*, 1988; *Above*: Robert Mapplethorpe, *Self-Portrait*, 1980

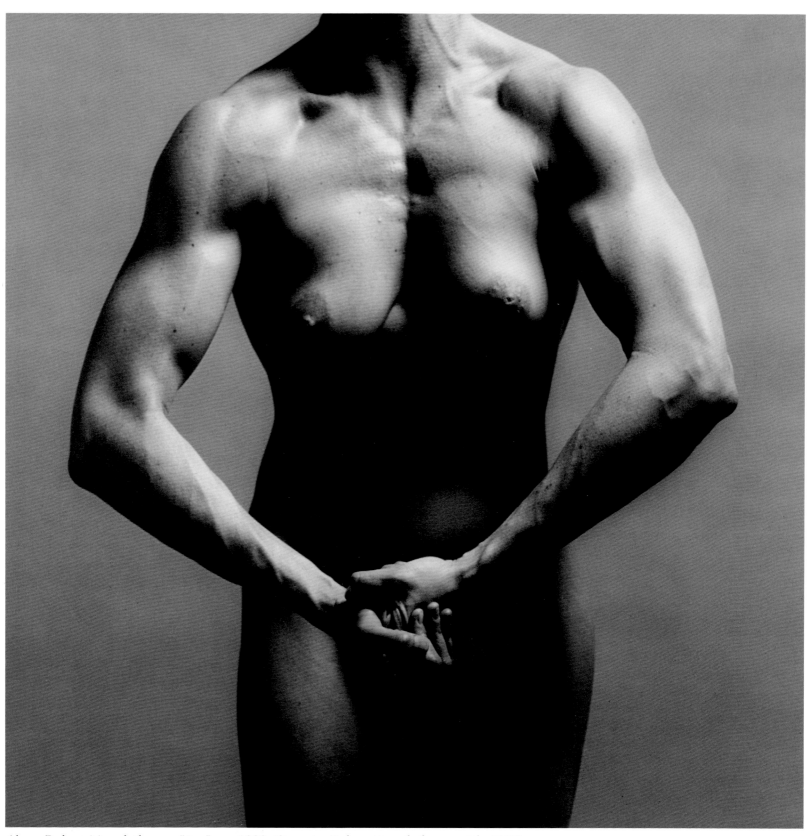

Above: Robert Mapplethorpe, *Lisa Lyon*, 1982; *Opposite*: Robert Mapplethorpe, *Ada*, 1982

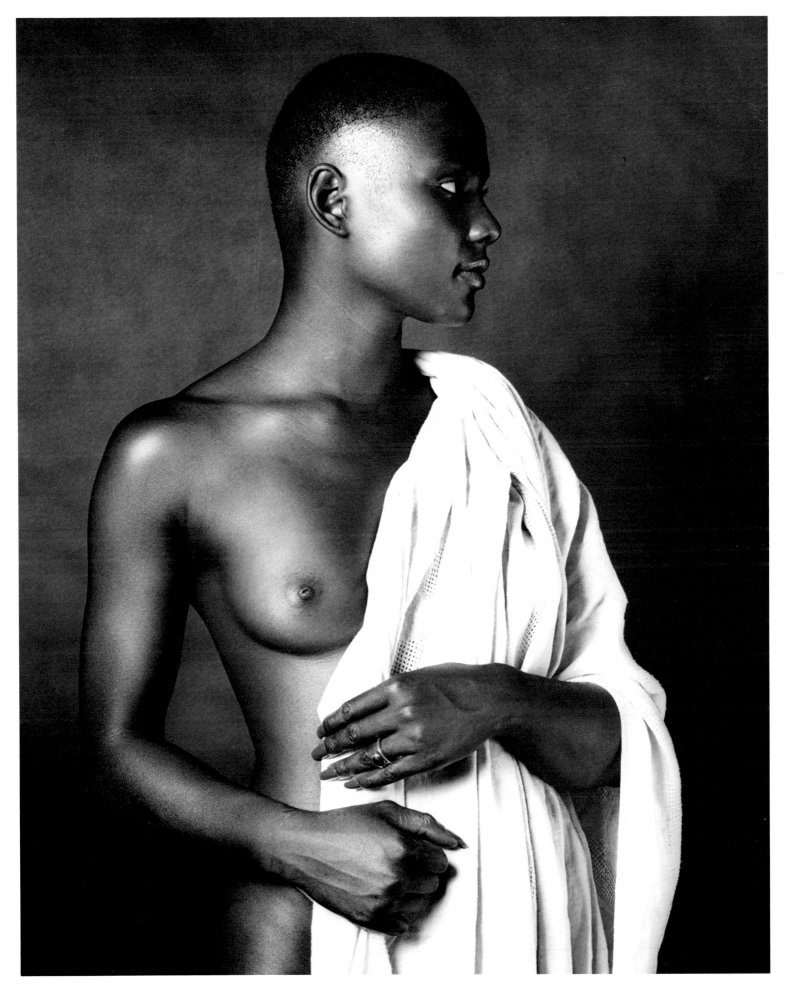

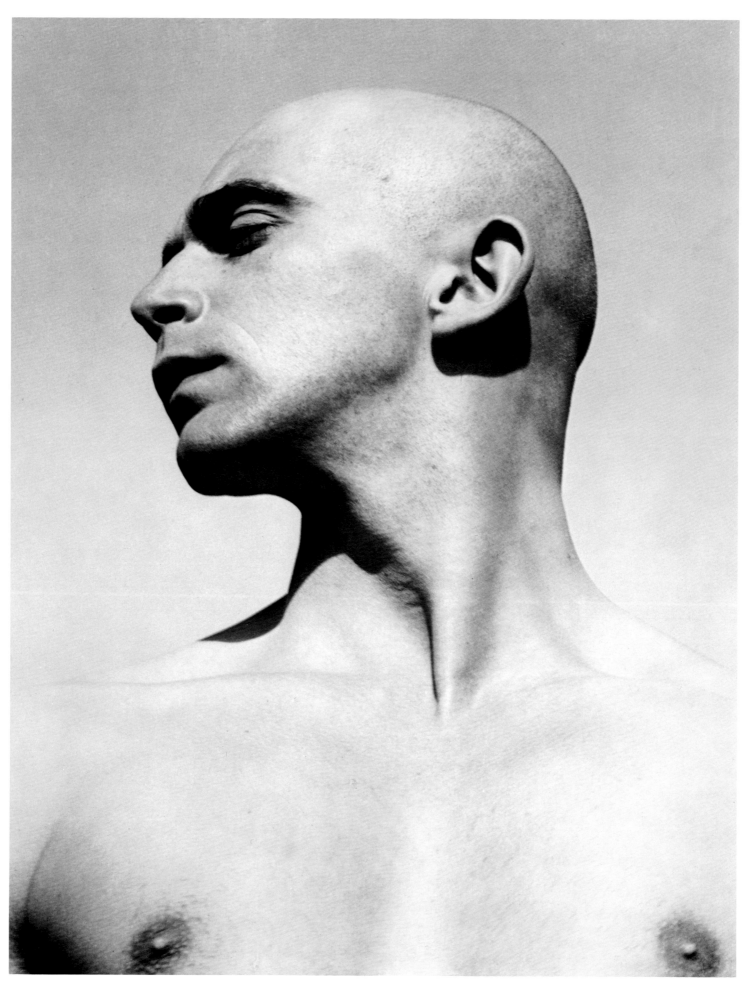

Edward Weston, *Harald Kreutzberg*, 1932

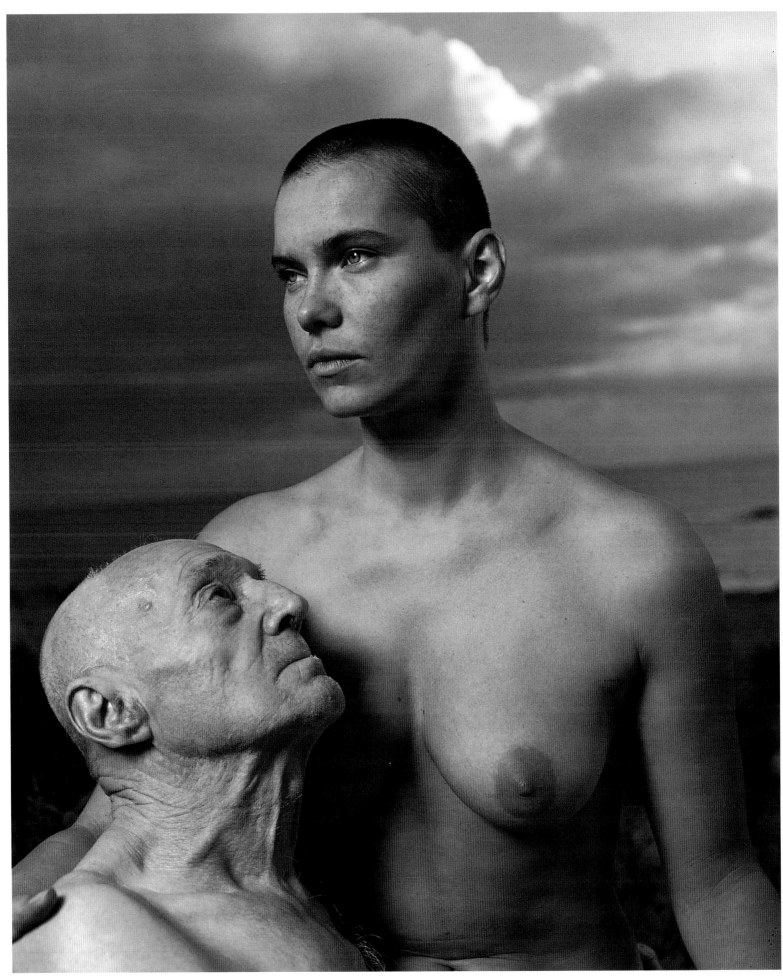

Andres Serrano, *A History of Sex (Antonio and Ulrike)*, 1995

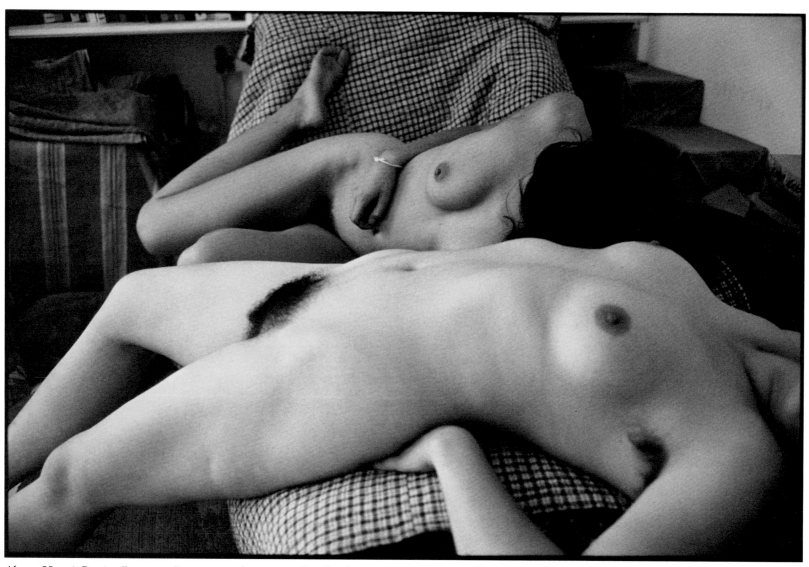

Above: Henri Cartier-Bresson, *Pause entre deux poses* (Resting between two drawing sittings), 1989; *Opposite*: Eikoh Hosoe, *Embrace #42*, 1969

Sally Mann, *Untitled*, ca. 1983–85

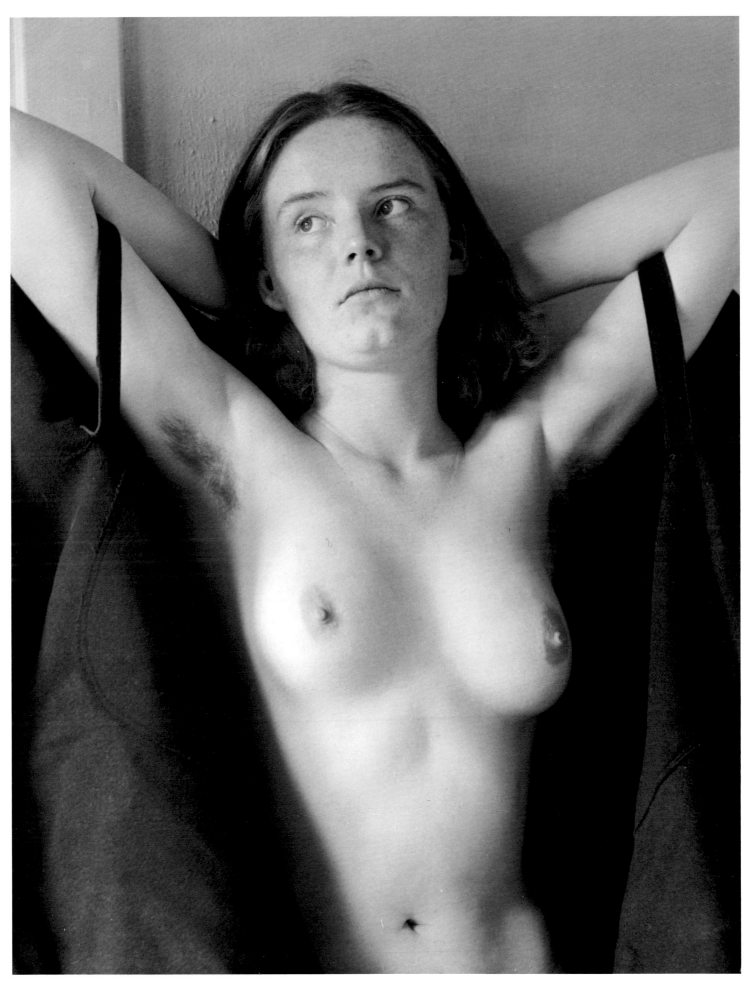

Edward Weston, *Charis Wilson*, 1935

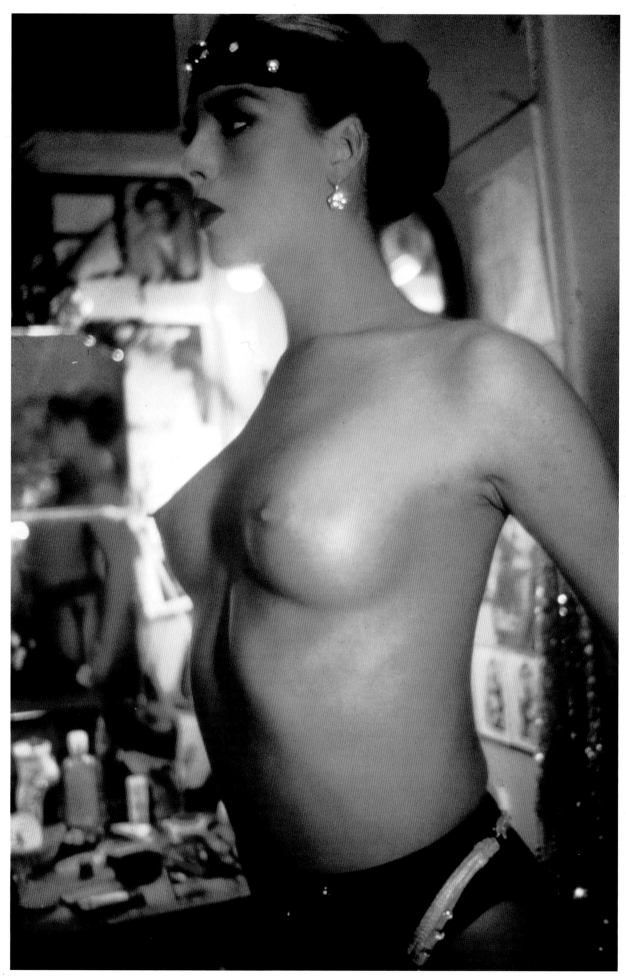

Nan Goldin, *Kim between Sets*, Paris, 1991

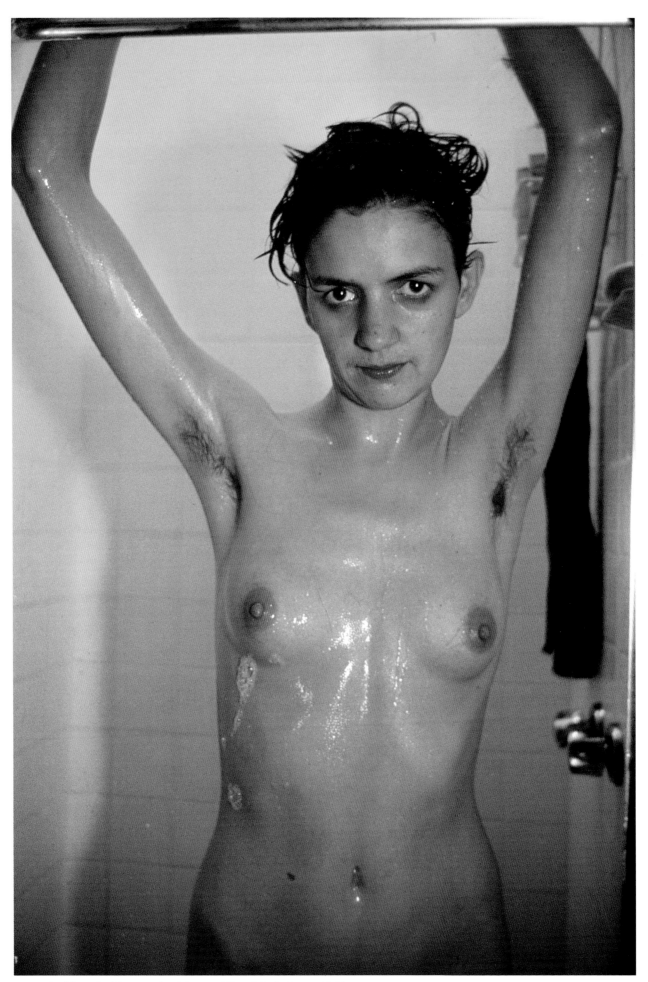

Nan Goldin, *Siobhan in the Shower*, New York City, 1991

CREDITS

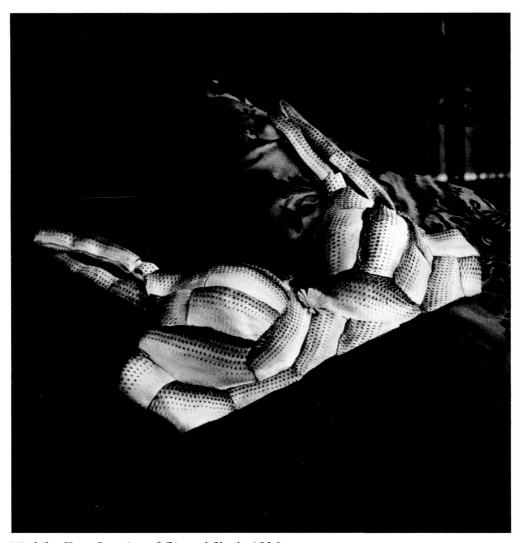

Michiko Kon, *Brassiere of Gizzard Shads*, 1986

"Goodnight moon. Goodnight house. Goodnight breasts."

Library of Congress Catalog Card Number: 98-84498
Hardcover ISBN: 0-89381-803-8

Design by Wendy Setzer

Printed and bound by Mariogros, Italy.
Duotone separations by Thomas Palmer.

THE STAFF AT APERTURE FOR *MASTER BREASTS*:
Michael E. Hoffman • EXECUTIVE DIRECTOR
Melissa Harris • EDITOR
Stevan A. Baron • PRODUCTION DIRECTOR
Lesley A. Martin • ASSISTANT EDITOR
Phyllis Thompson Reid • EDITORIAL ASSISTANT
Nell Elizabeth Farrell • EDITORIAL ASSISTANT
Helen Marra • PRODUCTION MANAGER
Cara Maniaci • EDITORIAL WORK-SCHOLAR
Steven Garrelts • PRODUCTION ASSISTANT

Thanks also to Diana C. Stoll and Sandra Greve for encouraging getting it off our chests.

Aperture Foundation publishes a periodical, books, and portfolios of fine photography to communicate with serious photographers and creative people everywhere. A complete catalog is available upon request. Address: 20 East 23rd Street, New York, NY 10010. Phone: (518) 789-9003. Fax: (518) 789-3394. Toll-free: (800) 929-2323.

Visit our website: http://www.aperture.org

Aperture Foundation books are distributed internationally through:
CANADA: General/Irwin Publishing Co., Ltd., 325 Humber College Blvd., Etobicoke, Ontario, M9W 7C3. Fax: (416) 213-1917. UNITED KINGDOM, SCANDINAVIA, AND CONTINENTAL EUROPE: Robert Hale, Ltd., Clerkenwell House, 45-47 Clerkenwell Green, London, United Kingdom, EC1R OHT. Fax: (44) 171-490-4958. NETHERLANDS, BELGIUM, LUXEMBURG: Nilsson & Lamm, BV, Pampuslaan 212-214, P.O. Box 195, 1382 JS Weesp. Fax: (31) 29-441-5054. AUSTRALIA: Tower Books Pty. Ltd., Unit 9/19 Rodborough Road, Frenchs Forest, Sydney, New South Wales, Australia. Fax: (61) 2-9975-5599. NEW ZEALAND: Southern Publishers Group, 22 Burleigh Street, Grafton, Auckland, New Zealand. Fax: (64) 9-309-6170. INDIA: TBI Publishers, 46, Housing Project, South Extension Part-I, New Delhi 110049, India. Fax: (91) 11-461-0576

To subscribe to the periodical *Aperture* in the U.S.A. write Aperture, P.O. Box 3000, Denville, NJ 07834. Phone: (800) 783-4903. One year: $40.00. Two years: $66.00.

For international magazine subscription orders for the periodical *Aperture*, contact Aperture International Subscription Service, P.O. Box 14, Harold Hill, Romford, RM3 8EQ, United Kingdom. Fax: 1-708-372-046. One year: $50.00. Price subject to change.

First edition
10 9 8 7 6 5 4 3 2